GOLF

IN

SEATTLE AND TACOMA

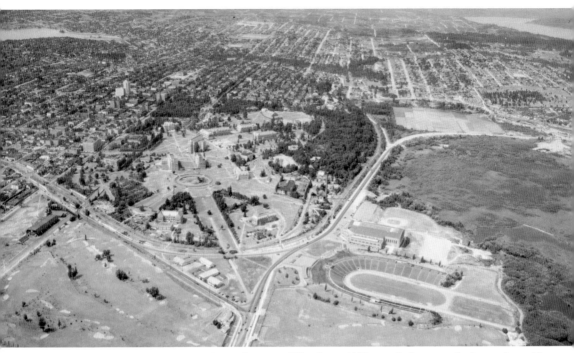

UNIVERSITY OF WASHINGTON GOLF COURSE. This June 1932 aerial photograph shows the golf course spreading out on both sides of Montlake Boulevard. The area to the left would eventually be taken over by the University Hospital complex. Husky Stadium is just above the golf course on the right. (Courtesy of University of Washington Special Collections.)

FRONT COVER: Stadium High School. Their castle-like high school bestows a stately background for these members of the Stadium High School golf team. They are, from left, (first row) Roland Hoar and Oscar Eliason; (second row) Elmer Nelson, coach Harry Swarm, and Sam York. Team member Chet Brown is not pictured. "Ockie" Eliason went on to become a two-time winner of the Northwest Open. This 1942 Stadium High Tiger team was the Cross-State League champions. (Courtesy of Tacoma Public Library.)

COVER BACKGROUND: Tacoma Open Golf Tournament at Fircrest Golf Course. Ed "Porky" Oliver took the prize at this four-day event in 1948. Oliver played on Ryder Cup teams in 1947, 1951, and 1955. He won eight tournaments on the PGA tour, including three in 1940. Known for his personality, Oliver was hired as head professional at Inglewood to bring in the crowds—and he did. (Courtesy of Tacoma Public Library.)

BACK COVER: Tacoma's Highland Golf Course. The Works Progress Administration subsidized a program to teach women to play golf. Golf professional Ray Ball (left) used these funds to introduce the sport to a group of women in August 1941. Shown with Ball are, from left, Helen Veatch, Inga Petersen, Mrs. Paul O. Brown, Mrs. James Enochs, Pat Ostland, Mrs. Augie Seymour, Mrs. Stuart Parks, Mrs. Fred W. Veatch, Mrs. Gilbert Caughran, and Marian Hager. (Courtesy of Tacoma Public Library.)

GOLF
IN
SEATTLE AND TACOMA

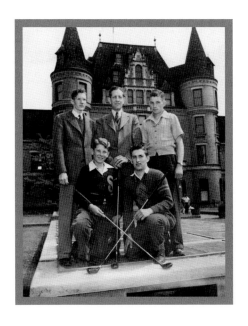

Debbie Sorrentino Kilgren and Neil E. Kilgren

ARCADIA
PUBLISHING

Published by Arcadia Publishing
Charleston, South Carolina

Printed in the United States of America

Library of Congress Control Number: 2015937083

For all general information, please contact Arcadia Publishing:
Telephone 843-853-2070
Fax 843-853-0044
E-mail sales@arcadiapublishing.com
For customer service and orders:
Toll-Free 1-888-313-2665

Visit us on the Internet at www.arcadiapublishing.com

To
Lee Sorrentino for his love of golf
and Ove Kilgren for his love of history

"The only cure for golf is golf."
—*Tacoma Times*, March 27, 1916

CONTENTS

ACKNOWLEDGMENTS

We wish to thank the following persons and organizations: Kwame Turner and Monette Hearn, Black Heritage Society of Washington State; the Bancroft Library, University of California, Berkeley; Historylink.org; Marysville-Pilchuck High School; Carolyn Marr, Museum of History and Industry; National Archives; Chronicling America, America's Historic Newspapers (chroniclingamerica.loc.gov); David Mazzeo, alumni director, O'Dea High School; Densho Digital Archive; Gerald R. Ford Presidential Library and Museum; Kerstin Ringdahl and the Robert A.L. Mortvedt Library, Pacific Lutheran University; Midori Okazaki, archivist, Puget Sound Regional Archives; Elizabeth P. Stewart, Renton History Museum; Julie B. Irick, photo archivist, Seattle Municipal Archives, City of Seattle; Jade D'Addario and Jodee Fenton, Special Collections, Seattle Public Library; the *Seattle Daily Times*; the *Seattle Times*; Marc Blau, Shanaman Sports Museum of Tacoma–Pierce County; the *Tacoma News Tribune*; the *Tacoma Sunday Ledger*; Jody Gripp, Special Collections, Tacoma Public Library; Kris Kinsey and Nicolette Bromberg, Special Collections Division, University of Washington Libraries; *USGA Journal and Turf Management*; Benjamin Helle, Washington State Archives; Fred Poyner, Washington State Historical Society; Pat Mueller, Washington State University Libraries; Robert Fisher, collections manager, Wing Luke Museum of the Asian Pacific American Experience.

The following publications proved invaluable in our research: *Fred Couples: Golf's Reluctant Superstar* by Kathlene Bissell; *Homer Kelley's Golfing Machine: The Curious Quest That Solved Golf* by Scott Gummer; *Jefferson Park Reconstructed: A 100-Year History*, produced by Jefferson Park Alliance; *Karsten's Way: The Life-Changing Story of Karsten Solheim* by Tracy Sumner; *Playground to the Pros* by Caroline Gallacci, Marc Blau, and Doug McArthur; *Six Roads from Abilene: Some Personal Recollections of Edgar Eisenhower* by John McCallum; and *Tacoma Country & Golf Club: 1894–1994*, compiled by Shirlee H. Smith.

Finally, we want to thank Sandee Didtel for her organizational skills and, especially, Matthew Todd, our editor at Arcadia Publishing, for his patience and prodding.

Although the authors are not currently golfers, they are affiliated with the PNGA as donors. All of the authors' proceeds from the sales of this book will be donated to the Greater Northwest Chapter of the National Multiple Sclerosis Society.

INTRODUCTION

When Chambers Bay Golf Course hosted the 2015 US Open Championship, it was the pinnacle for a sport that has been played along the shores of central Puget Sound for more than a century. The new links, built on the site of a gravel pit, had been open for just eight years when the eyes of the sports world turned to the Tacoma suburb of University Place. Thousands of spectators and millions of television viewers witnessed blue skies, beautiful scenery, top-notch play, and an exciting finish—and many gripes about the condition of the greens.

It is appropriate that such an event should take place in the Tacoma area, for it was here that golf was introduced to the Pacific Northwest in the early 1890s. The Tacoma Golf Club was formed in 1894, making it not only the first in the region but, reportedly, one of the earliest west of the Mississippi River.

That golf took hold here so early and has remained so healthy may seem odd at first glance, as the climate in the Seattle-Tacoma area does not seem conducive to playing an outdoor sport like golf. All that rain, and so little sunshine. While it rains about 155 days per year in Seattle and Tacoma, these showers are usually light, which means the annual rainfall is less than many other places in the country. Cities with more rain per year than Seattle and Tacoma include Boston, Atlanta, Houston, New York City, Miami, Washington, DC, Pittsburgh, Nashville, and Charlotte. Winters are mild, with temperatures averaging in the 40s, so golf is a year-round sport in this region. When golf started in the Pacific Northwest, it was more of a winter sport, and tournaments were often held on Thanksgiving and New Years Day. Before lawn mowers, the groundskeepers were the foraging animals who kept the prairie grasses manageable. Locals called golf "cow-pasture pool." Dry summer months made some of the golfing areas so parched that one golf stroke could cause a miniature dust storm.

The primary focus of *Golf in Seattle and Tacoma* is on courses and players of the early years. This book explores the rich history of this sport from the beginning, when the ancient Scottish game found its way to the Pacific Northwest, then shows how the sport suffered during the difficult years of the Great Depression and two world wars. It continues with a view of the golf courses and their clubhouses, inside and out. Then, the book features the players—the ordinary, the famous, and the eccentric. Finally, the book takes a brief tour of Chambers Bay.

The stunning photographs in these pages speak to the quality of local museums, libraries, and historical societies, which have nurtured and chronicled the region's stories.

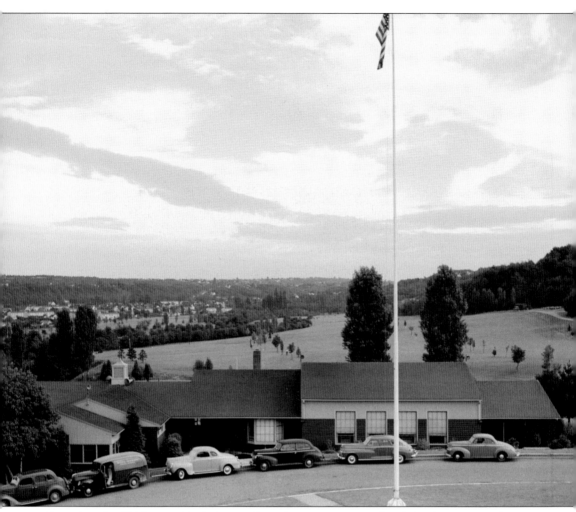

West Seattle Clubhouse, 1946. A presidential name was considered for the municipal course before it opened in 1940, in keeping with the precedent set by the previous public courses, Jackson and Jefferson. Other names suggested by club members were Chandler Egan Golf Course and Washington Golf Course, after the state. (Courtesy of Seattle Municipal Archives.)

BEGINNINGS

FATHER OF NORTHWEST GOLF, 1948. It all started in 1894, when golf-nostalgic Alexander Baillie built a prairie course on a south Tacoma cattle pasture. The businessman, educated at the University of St. Andrews, sent for clubs and gutta-percha balls from his native Scotland and rented 280 acres for $1 a year from the Eisenbeis family. Baillie became the first president of the Tacoma Country & Golf Club. At the urging of Fort Steilacoom Asylum superintendent Dr. Nathanial J. Redpath, who offered well-behaved patients as caddies, Alexander Baillie and H.L. Bremner built another nine-hole links on the asylum grounds, where they held a tournament in 1895. Transportation to the Steilacoom links was difficult, and this second course was too far from Tacoma to survive. Fort Steilacoom Asylum is now Western State Hospital. Pictured from left at TCGC are Baillie, Reno Odlin, and Audsley Fraser. (Courtesy of Tacoma Public Library.)

ALEXANDER BAILLIE, 1948. When the Tacoma Country & Golf Club founder, Baillie, died in 1949, *Seattle Times* golf writer William F. Steedman recalled a story about a shipment of golf clubs Baillie imported from Scotland in the late 1800s. A puzzled customs worker was unable to figure out how to categorize the odd sticks. Eventually, he classified the drivers, mashies, brassies, baffies, and cleeks as farm implements. (Courtesy of Tacoma Public Library.)

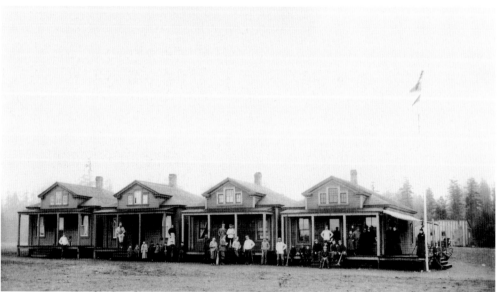

CLUBHOUSE, TACOMA GOLF CLUB, 1895. These four neighboring red houses became the first clubhouse. The property's owners lived in one dwelling and served as caretaker and cook. The other buildings were a club room, a men's locker room, and a women's dressing room. (Courtesy of Tacoma Public Library.)

BEGINNINGS

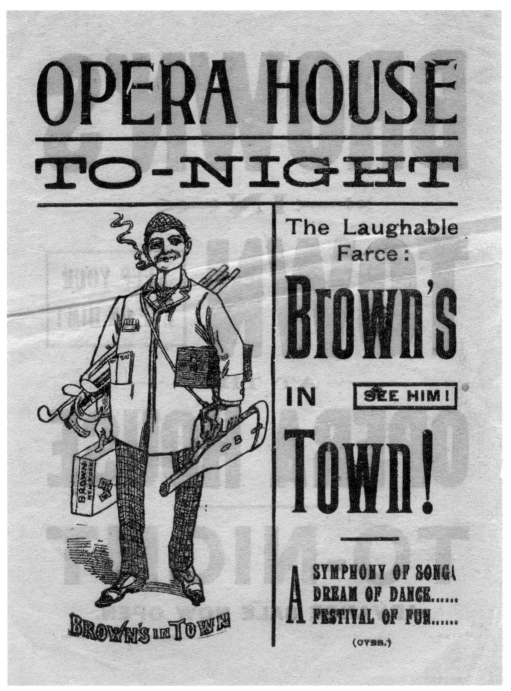

TACOMA OPERA HOUSE, 1898. Though most people in Washington State had never seen a golf club, the sport was beginning to spring up in contemporary culture before the turn of the century. *Brown's in Town* was a comedic play performed at the Tacoma Opera House in 1898. This poster depicts a chief character carrying a set of golf clubs. (Courtesy of Washington State Historical Society.)

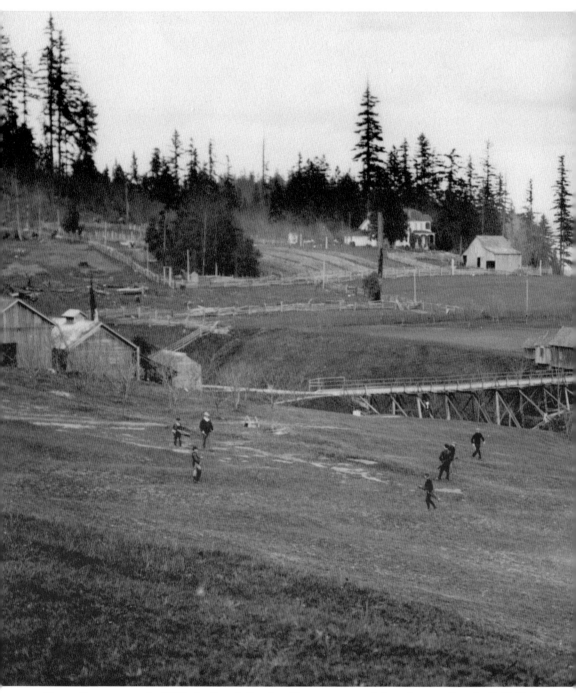

EARLY LOCATIONS. In 1896, the *Seattle Post-Intelligencer* reported that the new Seattle Golf Club had 35 gentlemen and 25 ladies. Their first men's single competition on the Fremont course (not pictured) yielded scores from 120 to 211. By 1899, they had a tiny clubhouse where lady members served tea every Friday and Saturday. In 1901, they moved to Laurelhurst, on farmland belonging to David Ferguson. The family's large farmhouse, pictured on the far right, became the clubhouse.

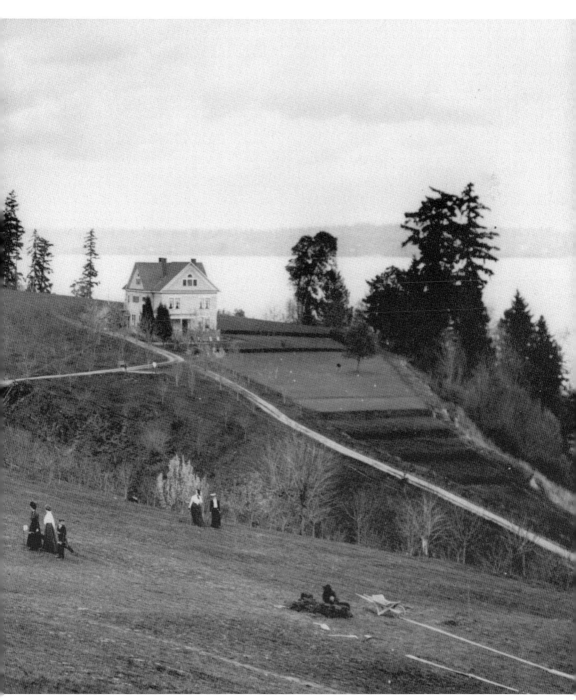

In 1908, the club moved to its current location in north Seattle. On March 24, 1910, the *Seattle Daily Times* ran this classified advertisement: "To Let—The old golf clubhouse, directly east of the University on Lake Washington; about 20 rooms; shower bath, hot and cold water, lighting plant; beautiful lawn; fine beach; excellent view; free wharf privileges. Suitable for summer hotel. $100 per month." (Courtesy of University of Washington Special Collections.)

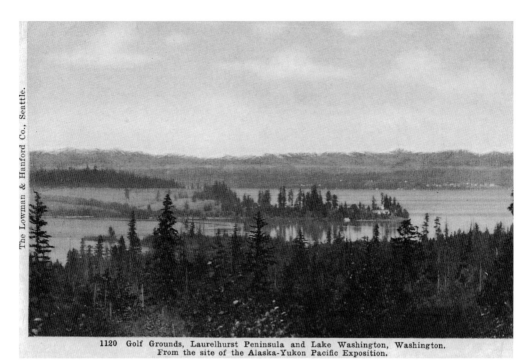

The Lowman & Hanford Co., Seattle.

1120 Golf Grounds, Laurelhurst Peninsula and Lake Washington, Washington.
From the site of the Alaska-Yukon Pacific Exposition.

ALASKA-YUKON-PACIFIC EXPOSITION. This postcard's view looks from the University of Washington toward Seattle Golf Club at its Laurelhurst location. The postcard was produced in conjunction with the Alaska-Yukon-Pacific Exposition, which was scheduled to occur on the campus in 1907. However, the fair was postponed until 1909. By that time, the Seattle Golf Club had moved to its north Seattle location. (Author's Collection.)

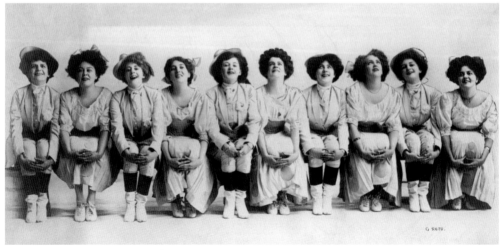

GOLF GIRLS. *Honeymoon Trail*, a stage musical, came to Seattle's Grand Opera House in 1909. Featuring the Golf Girls, it promised to provoke many laughs. The plot centered on Liberty Hall, a "divorce colony hotel," and the Sleepy Hollow Rest Cure for overworked businessmen. (Courtesy of University of Washington Special Collections.)

PRESIDENT TAFT, 1909. On the day designated as "Taft Day," 60,953 people attended the Alaska-Yukon-Pacific Exhibition in honor of the visiting president. After a brief reception at the Rainier Club in downtown Seattle, William Howard Taft visited the fair, located on the University of Washington campus. The golfing president then traveled to Seattle Golf and Country Club to enjoy a round on the links with Josiah Collins, a Seattle banker, who served as his caddie. Believed to be the first golfing president, Taft golfed at every possibility during his presidency. Some citizens deemed his playing obsessive. However, the attention he brought to golf was a tremendous boon to the sport. (Above, courtesy of Museum of History of Museum and Industry; below, courtesy of University of Washington Special Collections.)

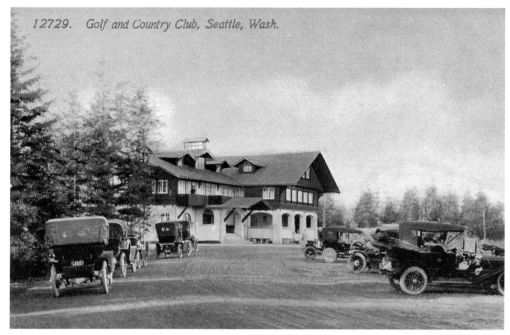

12729. Golf and Country Club, Seattle, Wash.

SEATTLE GOLF AND COUNTRY CLUB, 1910. The new clubhouse is pictured on this postcard. The club had relocated two years earlier to its third and final location, in The Highlands in north Seattle. Native fir and cedar trees had been preserved on the cleared land to maintain the natural beauty. The course, positioned on a high plateau, offered a panoramic view of Puget Sound, framed by the Olympic Mountains. (Author's collection.)

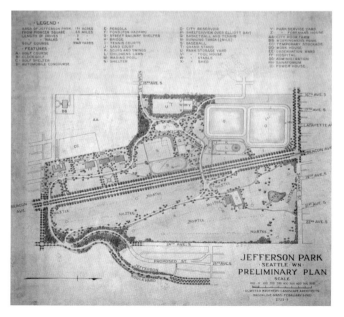

JEFFERSON PARK PLAN, 1912. In 1903, the City of Seattle hired the Olmsted Brothers to make a master plan for Seattle parks. Its plan for Jefferson Park included a golf course, reservoir, hospital, poorhouse, and workhouse. There was also a spot for clock golf, a circular putting area with 12 starting points for each hour on the face of a clock, with a hole in the middle a bit off-center to vary the putting lengths. (Courtesy of Seattle Municipal Archives.)

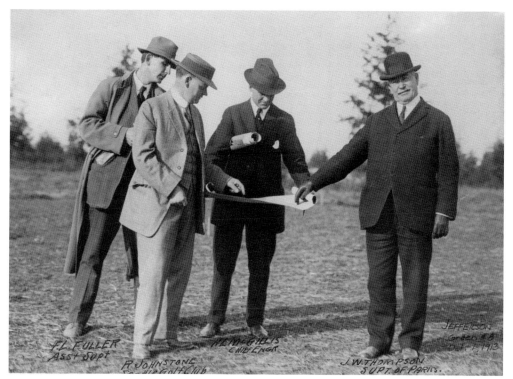

GOLF COURSE PLANNING, 1913. Shown here are, from left, Frank L. Fuller, Robert Johnstone, Henry L. McGillis, and J.W. Thompson. They are reviewing the plans for the municipal links at the Beacon Hill location of the future Jefferson Park course. Johnstone, the Seattle Golf Club professional, studied in his native Scotland. He became a master at club- and ball-making, course construction, greenskeeping, and shot-making. (Courtesy of Seattle Municipal Archives.)

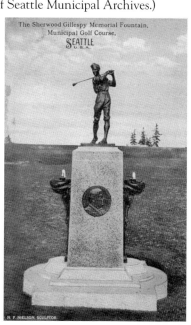

SHERWOOD GILLESPIE. Gillespie was an avid golfer and a community activist. He gave a dubious Seattle City Council a petition signed by thousands of businessmen, and this persuaded the council that a public golf course just might become self-sustaining and well-liked among regular folks. Jefferson Park Golf Course, the first municipal links in Seattle, opened in 1915. Gillespie was memorialized that same year with a bronze-and-stone statue, complete with two drinking fountains. The monument was placed on the first tee. (Author's collection.)

TACOMA SPEEDWAY—PROGRAM—July 4th

Gates open at 12 o'clock Program starts at 2:30 o'clock

Opening—Music by Sumner Military Band with patriotic and popular selections.

Event No. 1—First 50 mile heat of Aubry-Parsons $1000 Challenge Race.

Music by Band—"It's a Long Way to Tipperary."

Event No. 2—Fat Man's Ford Race. Entrants required to run 100 yards, crank their cars and make circuit of track.

Music by Band—"For He's a Jolly Good Fellow."

Event No. 3—Second 50 mile heat of Aubry Parsons $1000 Challenge Race.

Music by Band—"See the Conquering Hero Comes."

Event No. 4—Introduction of Engineers, Cooper and Ridgway

Music by Band—"Casey Jones."

Event No. 5—Grand Head-on Locomotive Collision and Leap for Life by Engineers.

Music by Band—"A Hot Time in the Old Town Tonight."
 (Meaning Stadium Show at 8:30—"The Stars and Stripes," which all should see.)

GOLF COURSE ADVERTISEMENT. This July 4, 1916, program for the Tacoma Automobile Speedway has an advertisement for Meadow Park Golf Course. This course opened in 1915, becoming the sixth Tacoma course and the only club within reach, via a 5¢ fare on the American Lake Traction car. Meadow Park Golf Course was privately owned but open to the public. It was Tacoma's first golf course for common people. (Courtesy of Washington State Historical Society.)

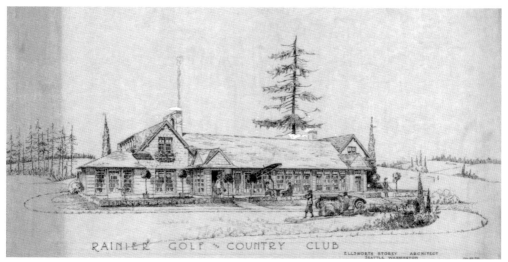

RAINIER GOLF CLUB. Architect Ellsworth P. Storey created this 1922 rendering of a clubhouse for Rainier Golf & Country Club. Initially inspired by Frank Lloyd Wright, Storey developed his own style, becoming an originator of realistic architecture. His distinctive method incorporated materials native to the Northwest, and he used the elegance of these local elements to help shape his creations. (Courtesy of University of Washington Special Collections.)

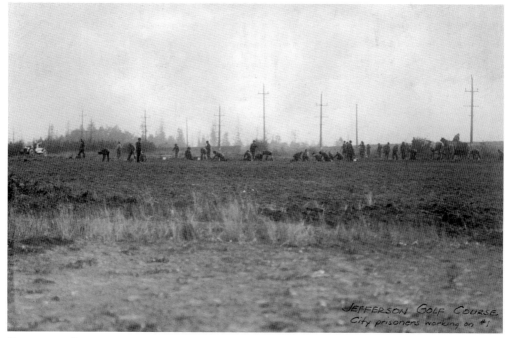

PRISONERS CLEARING LAND, 1915. Inmates serving short sentences at the city jail on Beacon Hill work as laborers on the first hole at Jefferson Park Golf Course. Expecting first-time duffers to visit the course, the *Seattle Star*, noting that most locals had never used a golf stick, warned veteran golfers, "Don't hog the municipal links. Give the hoi polloi a chance to learn." Jefferson Park celebrated its centennial in May 2015. (Courtesy of Seattle Municipal Archives.)

GOLF IN SEATTLE AND TACOMA

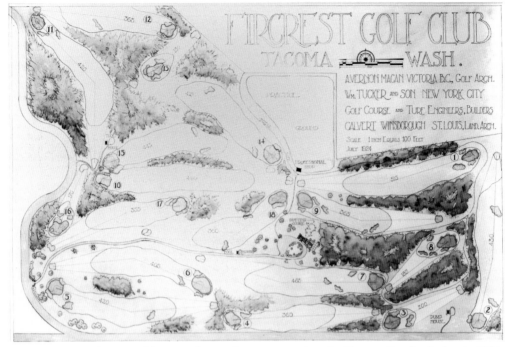

FIRCREST GOLF COURSE. The map shown above appeared in the *Tacoma Sunday Ledger* in 1924, in the same week that the course opened. The private course measured 6,455 yards, with a par of 70. Though the map shows eighteen holes, the course only had nine holes at the time. The Fircrest course, shown below in a 1930 aerial photograph, is still a thriving golf course in 2016. (Both, courtesy of Tacoma Public Library.)

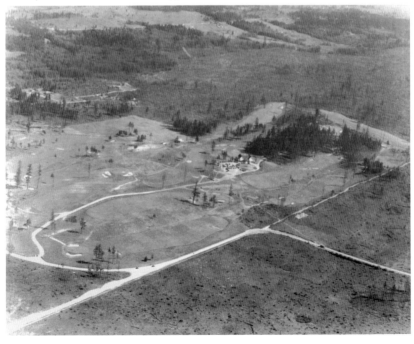

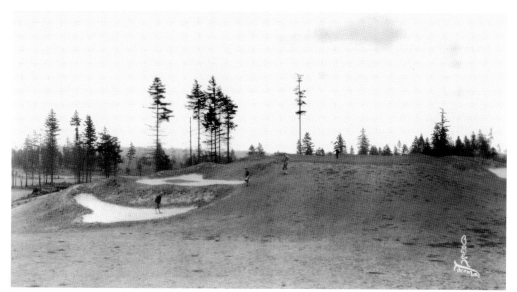

VOLCANO HOLE, C. 1924. The challenging 17th green was nicknamed "the volcano hole" by golfers at the newly built Fircrest Golf Course. Renowned golf architect A. Vernon Macon of Victoria, British Columbia, designed this tricky hole with Mount Rainier's landscape in mind. He believed that "a perfect putting green must, of course, provide interest and amusement for all." (Courtesy of Tacoma Public Library.)

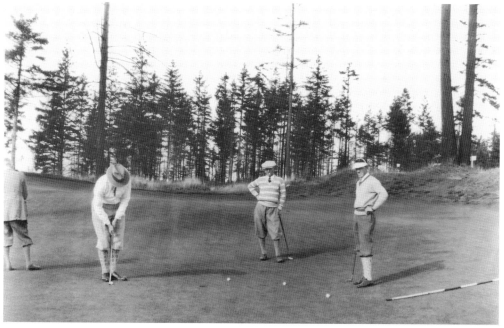

FIRCREST PUTTERS, 1926. Members of a stylish foursome are pictured putting on Fircrest's 10th green. The course architect, A. Vernon Macon, lost his lower left leg while fighting with the 88th Victoria Fusiliers in World War I. He continued to play golf and only gained two shots on his previous 4 handicap. (Courtesy of Tacoma Public Library.)

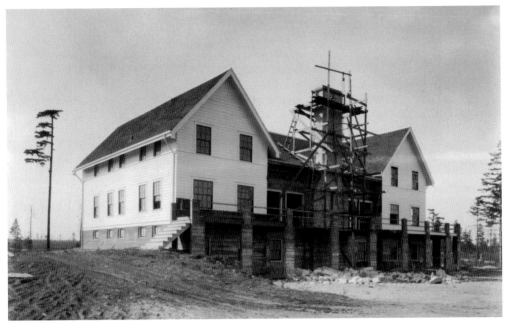

FIRCREST CLUBHOUSE. The first clubhouse at Fircrest Golf Course is seen near completion above in 1924. In later years, two more clubhouses would follow, the latest in 1997. Shown below is a postcard issued by the Tacoma Chamber of Commerce around 1927. The caption on the bottom reads, "18th hole and clubhouse of Fircrest, one of Tacoma's beautiful evergreen golf courses." Scottish-born George Turnbull, a Pacific Northwest golf champion, served as the club's first professional. The nationally recognized golfer died of a heart attack a short time later at age 45. (Both, courtesy of Tacoma Public Library.)

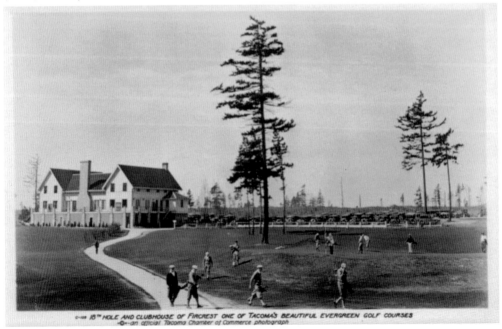

18ᵀᴴ HOLE AND CLUBHOUSE OF FIRCREST ONE OF TACOMA'S BEAUTIFUL EVERGREEN GOLF COURSES
—an official Tacoma Chamber of Commerce photograph

BEGINNINGS

STEILACOOM LAKE LINKS, MAY 1928. Still under development in this photograph, the public course opened in September 1928. It ran north and south, with a par 35 on the front nine and a par 37 on the back nine. The first nine holes were undulating, with plenty of traps. The course smoothed out on the last nine holes. In 1931, the *Seattle Daily Times* wrote that Steilacoom Lake Golf Course was "a pleasant afternoon for those inclined to the Scotch game." (Courtesy of Tacoma Public Library.)

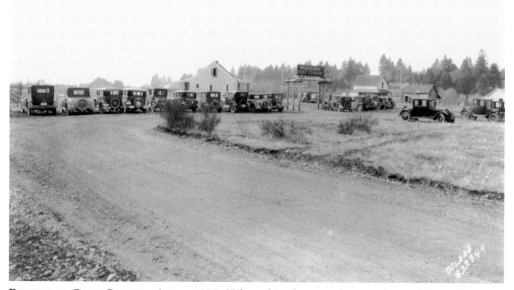

PARKLAND GOLF COURSE, APRIL 1930. When this photograph was taken at Tacoma's newest course, 300 trees had been planted. An additional nine holes would open later that year. The cars are parked near the club's main entrance. (Courtesy of Tacoma Public Library.)

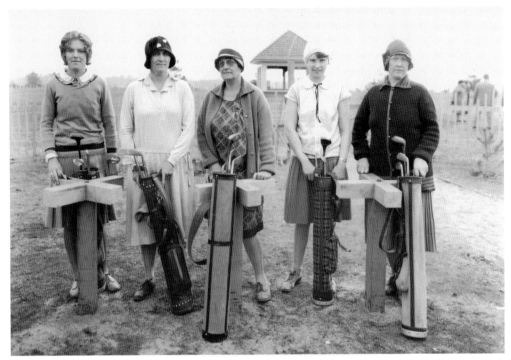

LADY GOLFERS. The plucky women at Parkland Golf Course unified to establish a women's division. Posing at the fledgling course in April 1930 are, from left, Adaline Sylvester, Mrs. Fred Sylvester, club president Adaline Flagg, Mrs. I.I. Stewart, and Mrs. Johan Xavier. The women's club scheduled tournaments with other golf clubs. (Courtesy of Tacoma Public Library.)

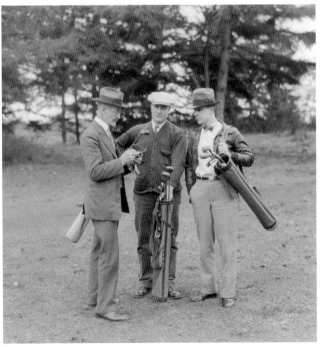

COLLEGE GOLF COURSE. Dr. Johan U. Xavier (left), president and instructor at Pacific Lutheran College, takes notes with fellow faculty member Dr. Ole J. Stuen (center) and an unidentified third golfer. Parkland Golf Course, near the college, opened in 1928 and, in 1936, became part of Pacific Lutheran College. Known as the College Golf Course after the transition, it was reduced from eighteen to nine holes. The course closed permanently in 2011. (Courtesy of Pacific Lutheran University.)

BEGINNINGS

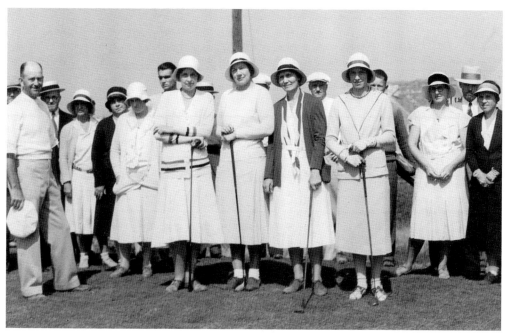

OPENING DAY, 1931. Dressed in apparel with hints of the Roaring Twenties, several women prepare to inaugurate Allenmore Golf Course during the golf-exhibition festivities. Situated on a rippling landscape, the 18-hole public club is still a popular year-round course. (Courtesy of Shanaman Sports Museum.)

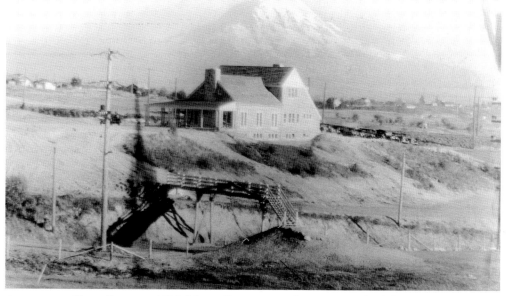

ALLENMORE GOLF COURSE, 1931. Mount Rainier provides a majestic backdrop for the clubhouse at Tacoma's Allenmore Golf Course. The club's name is a combination of the original owner's names, Sam Allen and D.W. Dinsmore. (Courtesy of Tacoma Public Library.)

HIGHLAND GOLF COURSE, 1931. A crowd gathers around the up-to-date clubhouse to celebrate the launch of Tacoma's latest golf course on June 20, 1931. It was called Highland Golf Course, because it was perched on a hill with magnificent views. It was fancy by public-course standards, and golfers could play 18 holes for only 50¢. That same day, a traditionally clad golfer (below) takes a swing on the tee box at this west side links, located at North Thirteenth and Pearl Streets. A half-century later, during one of its inactive periods, the abandoned Highland course fell into disrepair. Broomsticks were being used for flagpoles. The course was eventually rescued by Doug McArthur. (Both, courtesy of Tacoma Public Library.)

HARD TIMES

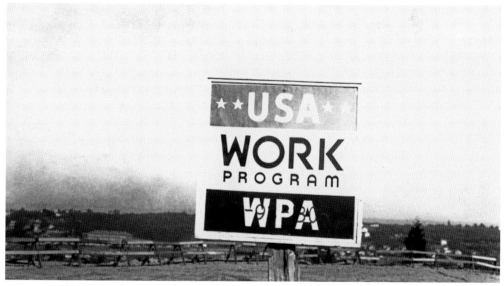

WPA AND GOLF. The two world wars and the Great Depression took a toll on the golf courses in Seattle and Tacoma. Club memberships declined, and some clubs became temporary homes for members of the military. But one local course came into existence and others enjoyed improvements through Depression-era public-works programs. This photograph was taken at the West Seattle Golf Course on October 5, 1936, near the start of construction of the facility. West Seattle was one of the 254 golf courses built through the Works Progress Administration (WPA), part of Pres. Franklin D. Roosevelt's New Deal. The federal program was started in 1935 to provide jobs and income to large numbers of unemployed during the economic downturn. (Courtesy of Seattle Municipal Archives.)

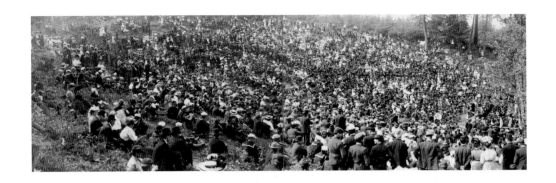

Naval Training Station, 1918. University of Washington president Henry Suzzallo granted the US Navy unrestricted use of the campus during World War I. The University Golf Course ceased operation and became a naval training center for men and women. President Suzzallo was a golfer and member of the Seattle Golf Club. Above, a large group gathers on the former golf links that had been converted to the training station. The naval camp is shown below, with Portage Bay in the background. The camp opened in 1917 and closed in 1919, after which the site transitioned back into the University Golf Course. Years later, it became the University of Washington Health Sciences Complex. An aerial view of the University Golf Course is found at the beginning of this book. (Both, courtesy of University of Washington Special Collections.)

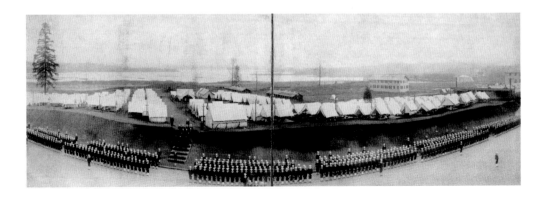

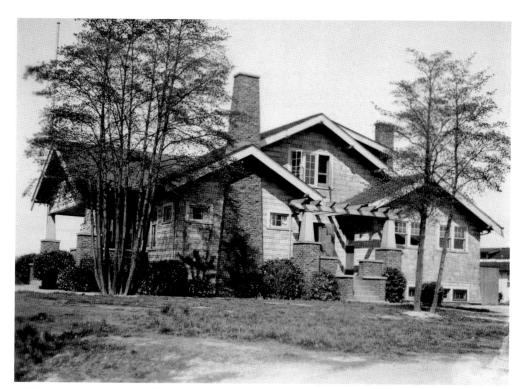

UW GOLF CLUBHOUSE. When the naval training camp closed at the end of World War I, the University of Washington reclaimed the acreage of its prewar golf links. Proponents for an arboretum vied for use of this property, but UW president Henry Suzzallo ruled in favor of the golf course. The former home of the naval station commandant, located along Lake Washington Ship Canal, became the new clubhouse in 1920. (Courtesy of University of Washington Special Collections.)

LAND CLEARING, 1936. Work began in the late 1930s to clear the land that would become the West Seattle Golf Course. The ground had to be graded, drained, landscaped, and seeded. This west-facing photograph shows clouds of smoke from the burning of cleared trees and stumps. Delridge Way is in the foreground. (Courtesy of Seattle Municipal Archives.)

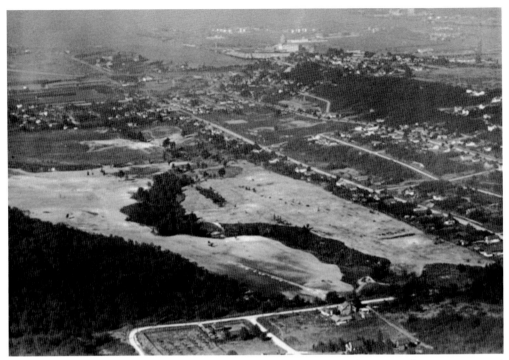

WEST SEATTLE, 1937. With some of the land cleared, construction began on the new municipal course. This photograph looks toward the northeast. West Seattle Golf Course opened in 1940. The city course withstood the test of time and is still a thriving operation. (Courtesy of Museum of History and Industry.)

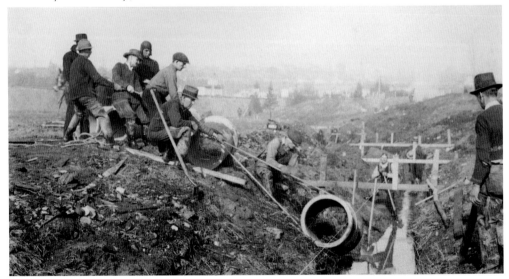

WPA WORKERS, 1937. Laborers install a sewer drainage system at the West Seattle Golf Course. The large amount of funding the West Seattle project received from the WPA is attributed in part to the influence of Pres. Franklin D. Roosevelt's daughter Anna Roosevelt Boettiger. She was married to the publisher of the *Seattle Post-Intelligencer*. (Courtesy of Seattle Municipal Archives.)

HARD TIMES

MUNICIPAL COURSE CONSTRUCTION, 1938. The West Seattle municipal course is a work-in-progress in this photograph. The layout was designed by renowned golf-course architect Henry Chandler Egan, who died near the beginning of the project in 1936. At the 1904 Summer Olympics in St. Louis, Egan won gold and silver medals in golf. (Courtesy of Seattle Municipal Archives.)

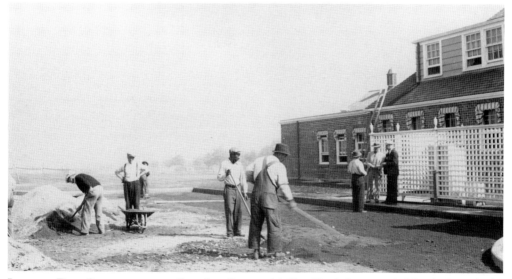

JACKSON PARK IMPROVEMENTS. President Roosevelt's New Deal also provided funds through the Public Works Administration (PWA). The workers in this 1936 photograph were paid through this program to make improvements at Jackson Park Golf Course. Years later, Tiger Woods would claim the course record. (Courtesy of Seattle Municipal Archives.)

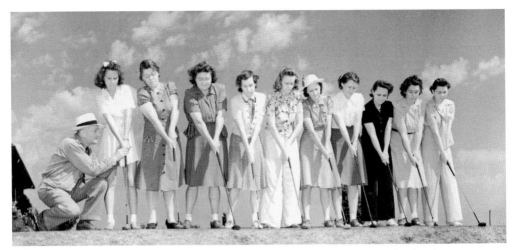

GOLF STUDENTS, AUGUST 1941. The Works Progress Administration subsidized a program to teach women to play golf. Golf professional Ray Ball (left) used these funds to introduce the sport to a group of women at Tacoma's Highland Golf Course. The women are, from left, Helen Veatch, Inga Petersen, Mrs. Paul O. Brown, Mrs. James Enochs, Pat Ostland, Mrs. Augie Seymour, Mrs. Stuart Parks, Mrs. Fred W. Veatch, Mrs. Gilbert Caughran, and Marian Hager. (Courtesy of Tacoma Public Library.)

THE FIGHTING MAYOR. Harry P. Cain (center) and his wife, Marjorie (far left), celebrate Halloween at the Tacoma Country & Golf Club in 1934. Cain became Tacoma's mayor in 1940. He took a leave of absence in 1943 to serve in World War II in Europe, where he was eventually assigned to the Supreme Allied Headquarters in London. After the war, he resumed his mayoral duties. In 1946, Cain won a seat in the US Senate. (Courtesy of Tacoma Public Library.)

HARD TIMES

RED CROSS VOLUNTEERS, 1943. The nation's entry into the war on December 7, 1941, had an impact on all Seattle-Tacoma golf courses. Tacoma Country & Golf Club stayed open, but membership declined when men went off to war. These Red Cross volunteers met Monday, Wednesday, and Friday in the TCGC clubhouse to make surgical dressings for the war injured. (Courtesy of Tacoma Public Library.)

WAR BONDS. Though many golf activities lessened during World War II, Fircrest's Co-Ed Club continued with its yearly back-to-school dance in August 1942. The event had a support-the-troops theme, and a war bond was awarded to the winner of the door prize. War savings bonds were used by the US government as a way to encourage voluntary contributions to the defense fund. (Courtesy of Tacoma Public Library.)

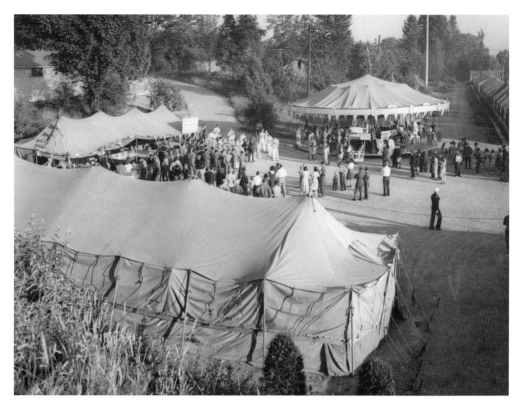

ARMY RECREATIONAL CAMP, 1943. To meet the need for housing due to the influx of soldiers to the Pacific Northwest, Jefferson Park and its golf course became an Army Recreational Camp. The Army used the site to provide accommodations and recreation for thousands of soldiers and their relatives. These photographs show families partaking in a weekend celebration, complete with carousel and penny arcade. Residents enjoyed arts and crafts, stage shows, and golf and other sports. (Both, courtesy of Seattle Municipal Archives.)

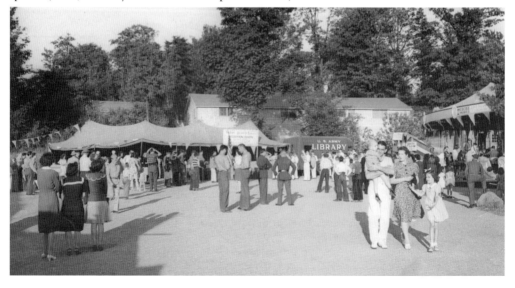

HARD TIMES

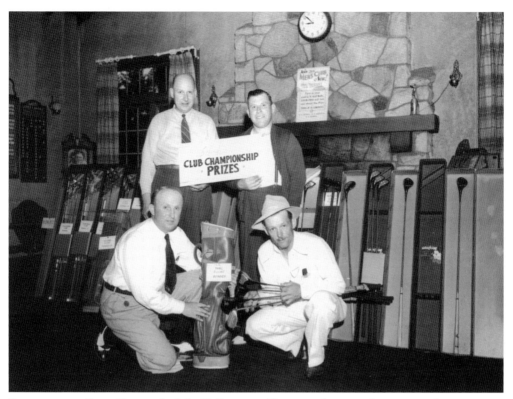

REPURPOSED GOLF BALLS. In July 1943, two golfers, standing amid an array of tournament awards, hold a sign reading, "Brookdale 1943 Club Championship Prizes." The sign on the mantel encourages golfers to turn in their old golf balls for a trade-in allowance, which could be used to acquire repurposed balls. This seems to be a way to circumvent the World War II golf ball shortage, created in 1942 when the government limited the sale of some rubber products. (Courtesy of Tacoma Public Library.)

BING CROSBY, 1942. Setting an example for the country, Bing Crosby donates a box of golf balls to aid the war effort. Scrap rubber and metal drives were common during World War II, which led to a shortage of golf balls and clubs. The singer appeared on a 1994 US postage stamp that listed his birth year as 1904. The correct year for Tacoma-born Harry Lillis Crosby is 1903. Crosby died on a Spanish golf course on October 14, 1977, at age 74. (Courtesy of National Archives and Records Administration.)

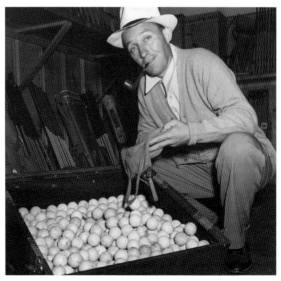

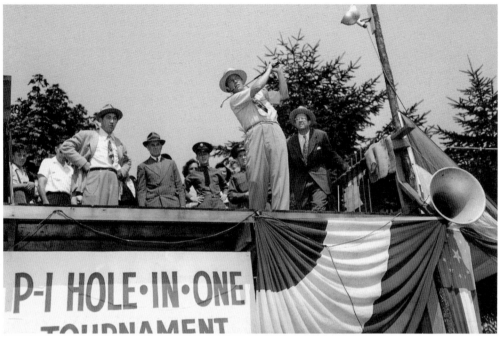

HOLE-IN-ONE TOURNAMENT, 1942. Bing Crosby takes his turn at a hole-in-one tournament in August 1942. For 50¢, participants purchased three shots from an elevated tee for a chance to make an ace. Proceeds from the event, sponsored by the *Seattle Post-Intelligencer*, purchased golf equipment for use by members of the armed services at Seattle's municipal golf courses. (Courtesy of Museum of History and Industry.)

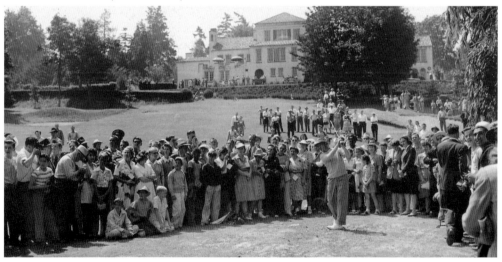

BROADMOOR GOLF CLUB, AUGUST 1942. The world-famous crooner Bing Crosby held a handicap that was as low as 2. Here, the singer is surrounded by fans at Broadmoor's nine-day tournament. Earlier, in 1937, Crosby started the National Pro-Am Golf Tournament. The pro-am, which paired Hollywood stars with professional golfers, was first televised in 1958 and was one of the most-watched golf tournaments for years. (Courtesy of Museum of History and Industry.)

3

ON THE COURSE

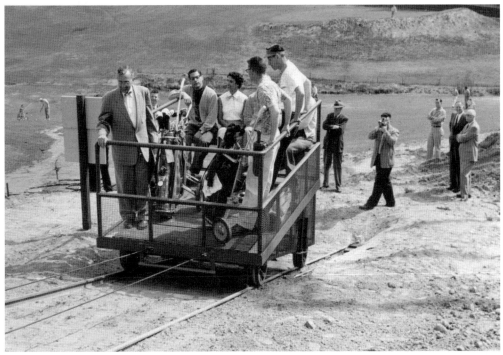

CARDIAC HILL, 1956. Passengers try out Jackson Park Golf Course's tram on the hill between the 11th and 12th holes. The new lift was called the Hillmaster, after builder C. Kirk Hillman and park official Pete Masterson. Golfers nicknamed the slope "Cardiac Hill" because of its steep incline. An extra 10¢ was added to the green fee to pay for this outdoor elevator. Riders in the cable car include, from left, Paul Brown, Kermit Rosen, and Pat Lesser. (Courtesy of Seattle Municipal Archives.)

SAND TEE, 1914. Although Jefferson Park Golf Course did not officially open until 1915, a few golfers give it a spin in this photograph, taken the previous year. The container between the two men, called a tee box, held wet sand. A golfer would take a handful of this moist sand and form it into a mound, which served as a makeshift tee. (Courtesy of Seattle Municipal Archives.)

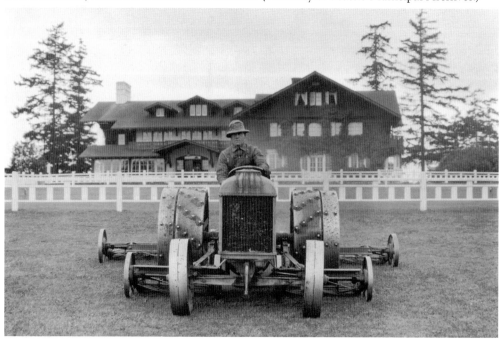

RIDING MOWER, 1922. Shown here is an early lawn mower at Seattle Golf Club, at its current location in The Highlands. Before the advent of lawn mowers, golfers relied on grazing animals to keep the ground cover under control. Initially, golf in Seattle-Tacoma was more of a winter sport, because foraging animals could not sufficiently keep up with the fast-growing vegetation during the lush summer months. (Courtesy of Museum of History and Industry.)

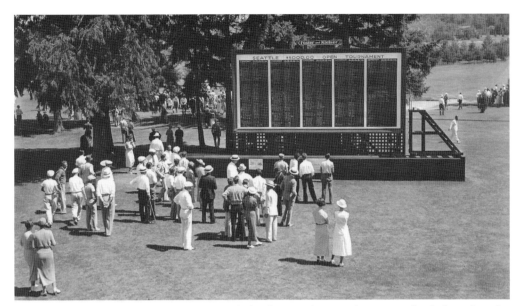

SEATTLE OPEN, AUGUST 1936. A crowd checks out the standings on a leaderboard at the Inglewood Golf Club. Scottish-born Macdonald Smith took the $5,000 prize at the first Seattle Open with a 65, eight under par. (Courtesy of Museum of History and Industry.)

STUMP REMOVAL. To get rid of tree stumps, workers in this undated photograph used dynamite, a common practice in golf-course maintenance through the first half of the 20th century. It was the preferred way used by course architects to remove large rocks and recalcitrant stumps, as well as to loosen compacted soil to help tree-root growth. Here, a worker carefully hands a bundle of dynamite to another man for placement under a stump at the West Seattle Golf Course. The others do not seem too worried, although the practice came with its share of danger. (Courtesy of Seattle Municipal Archives.)

SPECTATOR SPORT, 1937. Tacoma Country & Golf Club hosted an intercity open golf sweepstakes the same month that this photograph was taken. In all, 67 competitors each paid a $1.50 entry fee. Seattle's Bob Connolly and Tacoma's Verne Torfin split first prize in the professional division, with 71s, one below par. (Courtesy of Tacoma Public Library.)

RAIN BIRD, 1939. Here, two men inspect a newfangled sprinkler at West Seattle Golf Course. The horizontal-action impact sprinkler was patented in 1935 and sold under the brand name Rain Bird. These sprinklers were popular on golf courses, because they were durable and distributed the water evenly. Modern variations of Rain Bird sprinklers are still used on courses today. (Courtesy of Seattle Municipal Archives.)

ON THE COURSE

TEE WITH A VIEW. The Seattle Municipal Archives lists the above photograph as Jefferson in 1944 and the below photograph as Jackson in 1970. But these pictures, taken 26 years apart, look like the same site on the same course. (Both, courtesy of Seattle Municipal Archives.)

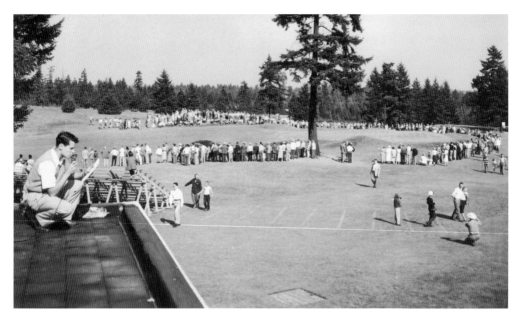

SUDDEN DEATH, 1948. Using a roof as a lookout (above), an announcer broadcasts the current standings at the Tacoma Open Golf Tournament. Inglewood Country Club's Ed "Porky" Oliver triumphed at the Fircrest Golf Club event after an exciting tie-breaking playoff. After 72 holes, five golfers were tied with 274 strokes. They played 18 holes the next day, ending in another draw. In a 19th-hole sudden death, Oliver prevailed. The event, sponsored by the Tacoma Athletic Commission, drew a large crowd. Below, people gather around the registration point. (Both, courtesy of Tacoma Public Library.)

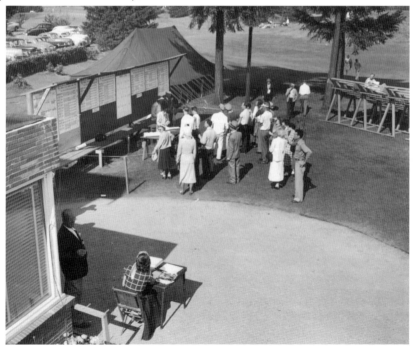

Exclusive Community, 1955.
This photograph was taken
by Josef Scaylea, a well-known
Seattle Times photographer. A
1924 advertisement in the *Seattle
Times* read, "THE PUGET
MILL COMPANY is pleased
to announce the Residential
District and Golf Course at
Broadmoor have been surveyed
and staked. Broadmoor is the
only exclusive Golf and Country
Club and private residential park
located within the corporate
limits of any metropolitan city
in the United States." (Courtesy
of Washington State Library.)

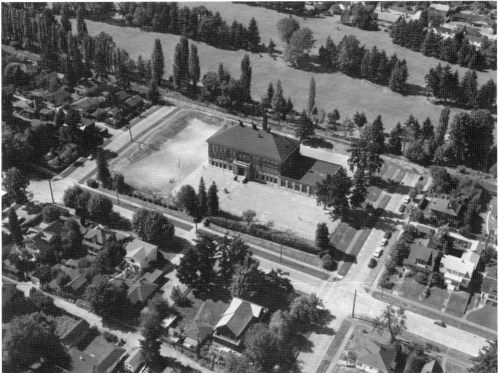

"Country Club within a City," c. 1960. Broadmoor Golf Course, located behind J.J. McGilvra
Elementary School, opened in 1927. Frank Rodia, who played on the Ballard High School golf
team, became the club's first professional. Near Washington Park Arboretum and abutting the
shores of Lake Washington, the Broadmoor gated community flourished after World War II.
(Courtesy of University of Washington Special Collections.)

COLLEGE GOLF. The University of Washington Golf Club, which formed in 1913, had 280 members by 1915. Golfers from outside the campus could also join. The above photograph of the new clubhouse appeared in *Tyee*, the university's yearbook. Students paid $1.50 per semester to play at the nine-hole course. In 1947, the university began building the UW School of Medicine next to Portage Bay on the golf course grounds, and the links began to slip away. A few holes remained for a while, until they, too, were swallowed up by the medical complex. Not ready to give up the links, the golfer pictured below in 1953 takes a swing on the vanishing course in front of the new Health Science Building. (Both, courtesy of University of Washington Special Collections.)

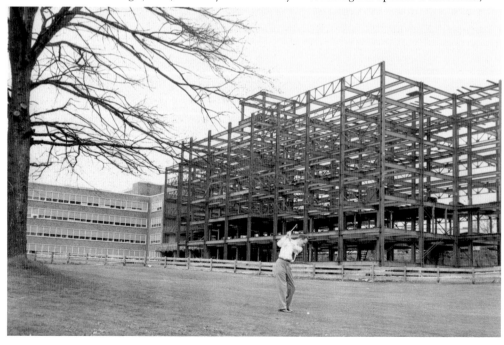

ON THE COURSE

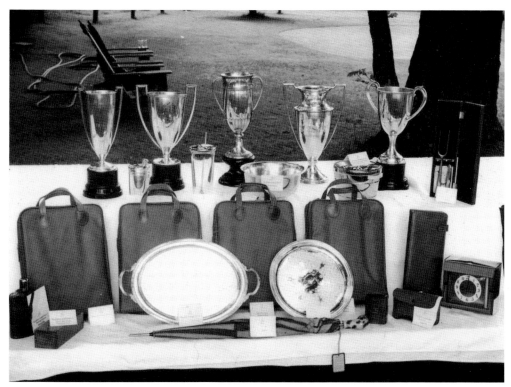

LUMBERMEN'S TOURNAMENT, 1948. These are the trophies awarded to the winners of the 25th annual Northwest Lumbermen's Golf Tournament, held in August 1948 at the Tacoma Country & Golf Club. Dave Doud, Tacoma city amateur champion, won with a 2-under-par 70. Members of the Pacific Northwest lumber industry were among the first classified vocations or professions to sponsor tournament play. In 1948, 150 lumbermen participated in the midsummer event. (Courtesy of Tacoma Public Library.)

U-SHAPED GOLF COURSE, 1952.
The Sand Point Country Club, shown here at upper right, is laid out in a semicircle surrounding an oval housing development. Visionary developer Samuel Hayes plotted this configuration in the 1920s. The golf course opened on the Fourth of July in 1927. The Great Depression delayed the growth of this housing community, which started emerging in the early 1940s and prospered after World War II. (Courtesy of Seattle Municipal Archives.)

PITCH 'N' PUTT CONSTRUCTION, 1947. Avid golfer Gloria Hemrich leased land from the park board to build a miniature-golf course on the south end of Seattle's Green Lake. This site, originally swampland, was filled with displaced dirt from the excavation of land used to build Aurora Avenue. Called Pitch 'n' Putt, the nine-hole course opened in March 1948. The holes ranged from 55 to 115 yards, for a total yardage of 745. (Courtesy of Seattle Municipal Archives.)

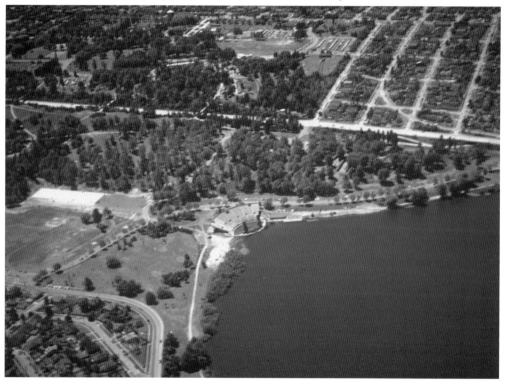

PITCH 'N' PUTT, 1970. Green Lake's little course (lower left) is still operating today. Visible above the course, near the water, is the outdoor Aqua Theater, which hosted big names, including renowned golfer and entertainer Bob Hope. The comedian often used a golf club as a prop. Hope played on local courses when in town. The amphitheater's fan-shaped bleachers were separated from the stage by water, and the venue featured a floating orchestra pit. (Courtesy of Seattle Municipal Archives.)

ON THE COURSE

GOLF COURSE FOR SALE, 1957. The fan-shaped feature at lower right is Auto View Drive-in. Above this outdoor theater, located in west Tacoma not far from the Tacoma Narrows Bridge, is a patch of land that has been a Highland golf course, with different configurations and operating under various names, since 1931. A 1961 newspaper advertisement read, "Highland Golf Course, right in center of Tacoma. Gently rolling land with a terrific view. Perfect for subdivision. 120 wonderful acres and priced to sell." (Courtesy of Tacoma Public Library.)

JACKSON PARK GOLF COURSE, 1960. The municipal course was named for Pres. Andrew Jackson, a Democrat. Some wanted to name it after golf advocate Albert S. Kerry or park commissioner James R. Stirrat, who said, "Golf helps one to forget his troubles—that is, his other troubles." The frontrunner for a name was Taft, in honor of Republican president William H. Taft. When a surprised *Seattle Times* announced on March 28, 1930, that Jackson would be the name of the park, they wrote, "the Democrats won again." (Courtesy of Seattle Municipal Archives.)

MEADOWBROOK GOLF COURSE, c. 1961. This photograph was taken after the Seattle Parks Department purchased the course that would eventually become Nathan Hale High School and a Meadowbrook playfield. Ruth Jessen got her start at the privately owned public course. She golfed and worked at the nine-hole, 40-acre links. She went from weeding the course to joining the men's golf team at Seattle University. Jessen turned pro in 1956 and had 13 professional wins. (Courtesy of Seattle Municipal Archives.)

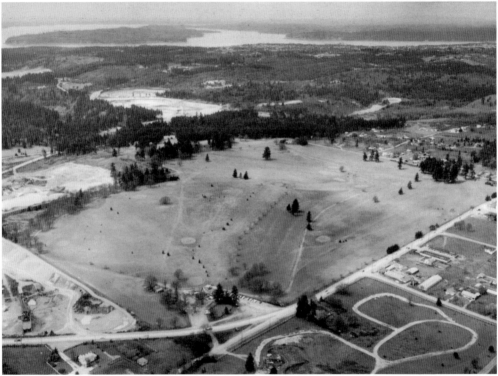

MEADOW PARK GOLF COURSE, 1961. Every day is Ladies' Day at this Tacoma course, which has allowed women to golf seven days a week since it opened in 1915. An explosion destroyed the first clubhouse months before this photograph was taken. In 2015, to celebrate the public course's 100th anniversary, golfers could rent century-old hickory clubs from Scotland and play a round with the wood-shafted golf sticks. (Courtesy of Tacoma Public Library.)

ON THE COURSE

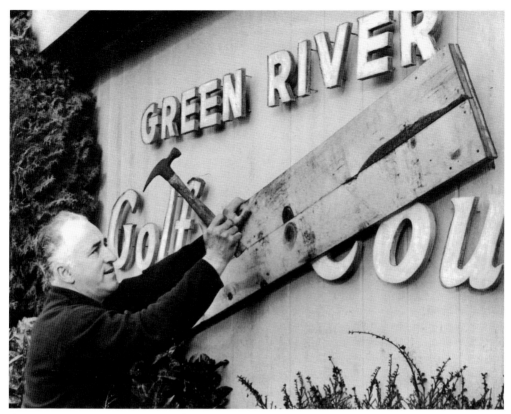

CHANGE AT GREEN RIVER. Guido "Torp" Peluso conceals the Green River Golf Course sign in 1969, when the 18-year-old course transitioned into the new Auburn Golf Course. The course was enlarged and reconfigured by golf architects Goss, Proctor & Bauman. Peluso, who once won a golf tournament using a woman's putter, served as golf professional at both courses. (Courtesy of Tacoma Public Library.)

FORWARD THRUST FUNDS. Jackson Park Golf Course, seen here in 1970, received $175,000 from King County's Forward Thrust bond issue to improve facilities and expand the clubhouse. Jefferson Park Golf Course also received $175,000, and West Seattle Golf Course received $1,238,000. When the voters passed the $118 million parks bond issue, it was the highest bond issue ever approved for parks and recreation in the country. (Courtesy of Seattle Municipal Archives.)

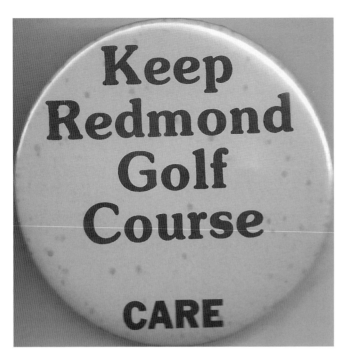

SAVE THE GOLF LINKS.
Built in 1932, the Redmond
Golf Course was sold for
development in 1978, but
it remained vacant and
overgrown for most of the
next two decades. This led
to a divisive city government
that debated for years about
the future of the municipal
links. A grassroots effort to
save the course, reflected in
this green campaign button,
proved unsuccessful. In 1997,
the site became Redmond
Town Center, an open-air
shopping and business center.
(Author's collection.)

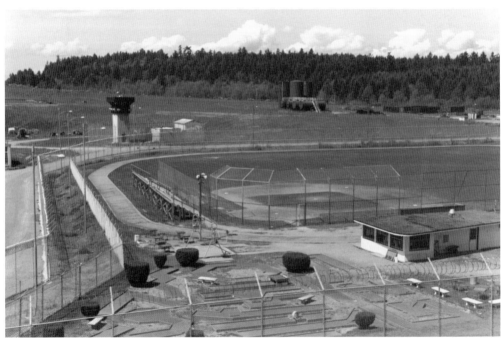

McNEIL ISLAND, c. 1980. Located in Puget Sound and visible from Chambers Bay Golf Course, McNeil Island was the home of McNeil Island Corrections Center at the time of this photograph. The outdoor recreation facility provided prisoners with the opportunity to play miniature golf (bottom of the photograph) under the watchful eyes of armed guards stationed in the lookout tower at upper left. (Courtesy of Washington State Library.)

ON THE COURSE

CLUBHOUSES

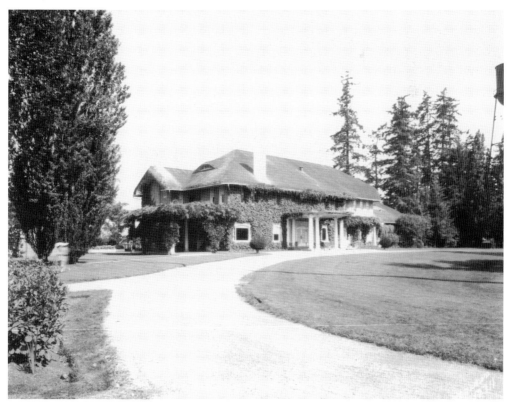

GRAND OLD LADY. Tacoma Country & Golf Club's ivy-covered clubhouse, pictured in 1925, earned the nickname "Grand Old Lady." The previous clubhouse was destroyed in 1909, when a fire that started in the servants' quarters spread to the main building. The pictured clubhouse was also devastated by fire when a fireplace spark landed on a rug and touched off a blaze in 1961. A third clubhouse opened in 1964. At the time it was built, the 26,000-square-foot structure was the largest building in Tacoma. (Courtesy of Tacoma Public Library.)

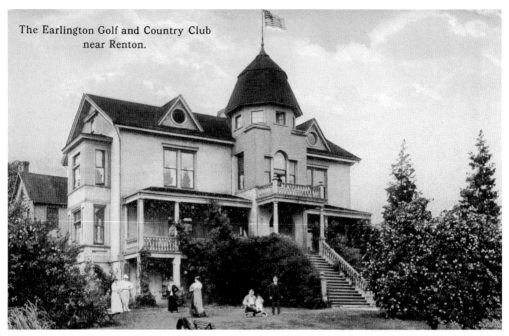

The Earlington Golf and Country Club
near Renton.

EARLINGTON CLUBHOUSE, 1917. This postcard shows the building that served as the clubhouse for Renton's Earlington Golf and Country Club for many years in the early 1900s. Originally the Bagley mansion, the house was constructed in the early 1880s. After a new clubhouse was built in the 1920s, the mansion became a rooming house and community center until the landmark structure was demolished in 1951. (Author's collection.)

$50,000 CLUBHOUSE. Earlington Golf and Country Club scrapped its old course and built a new, 18-hole course. The old clubhouse was too far away, so the club constructed this building, which opened in 1926. This photograph was taken three years later, in 1929. (Courtesy of Renton Historical Society.)

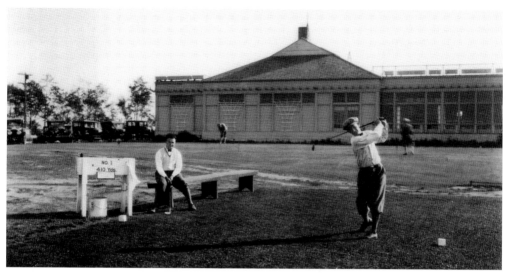

OLYMPIC GOLF CLUB. In the early 1950s, this course, located just north of Ballard, produced a crop of caddies, including Don Bies, with extraordinary golfing talents. In 1950, Jerry Fehr defeated Dale Lingenbrink, a fellow caddie who lived down the street, to become Washington's Junior Boys' champion. Then, 28 years later, Lingenbrink's son David topped Fehr's son Rick to gain the City Junior Championship title. By that time, the elder Fehr and Lingenbrink were employed with the same insurance company, and their sons were cousins. The former caddies had married sisters. Olympic Golf Club, seen above in 1925, later changed its name to Olympic View Golf Club. The course closed in 1953. Rick Fehr turned pro in 1984 and won the British Columbia Open in 1986 and the Walt Disney World Oldsmobile Classic in 1994. Shown below are Electric Club golfers in 1952. (Above, courtesy of Museum of History and Industry; below, courtesy of Seattle Municipal Archives.)

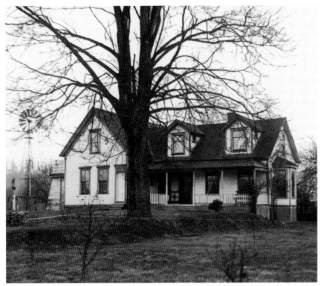

FOSTER CLUBHOUSE, C. 1930. Foster Golf Course opened in 1925 as a privately owned, pay-as-you-enter golf course, built on land settled by Joseph Foster. The Foster family farmhouse (pictured) became the golf clubhouse. Joseph Foster planted a maple tree on the property eight years after the end of the Civil War. The golf course is now a municipal course in Tukwila; the maple tree is still there. (Courtesy of Museum of History and Industry.)

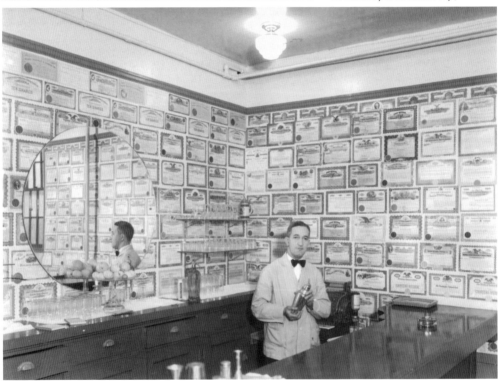

CLUBHOUSE BAR. Bartender Reed Harris mixes a drink in 1935. US Prohibition, which had banned the sale of alcohol beginning in 1920, had ended two years earlier, in 1933. The wallpaper in this room at Tacoma Country & Golf Club is made up of $8 million of old stock certificates, worth less than face value. Donated by members, most of the securities were issued by Tacoma business endeavors that did not work out, a common occurrence during the Depression. (Courtesy of Tacoma Public Library.)

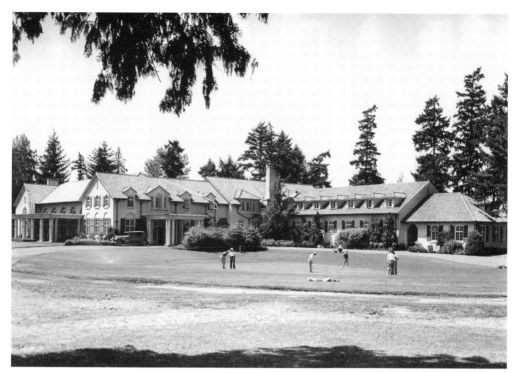

INGLEWOOD CLUBHOUSE, 1936. This golf course, located in Kenmore, hosted the first professional tour event in the Pacific Northwest, in 1936. Macdonald Smith, one of the era's top players, was the winner, taking home $5,000. Also that year, Seattle's Harry Givan competed on the Walker Cup team. (Courtesy of Museum of History and Industry.)

THE GREAT GUNDY. Juanita Golf Club, which opened in 1932, produced one of the state's winningest golfers, JoAnne Gunderson Carner. In the 1950s, Carner worked at the club and honed her golf skills at night. She became the only female to win the US Girl's Junior, US Women's Amateur, and US Women's Open. The Kirkland club, shown here in 1945, closed in 1975 and became a popular park. (Courtesy of Museum of History and Industry.)

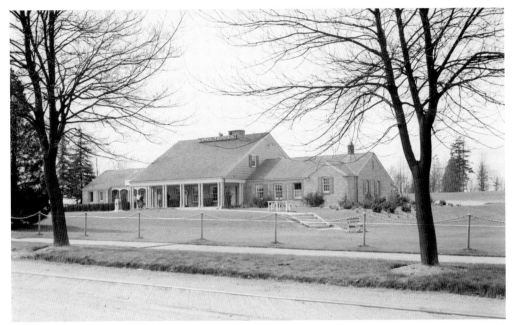

4100 BEACON AVENUE. The sign on the top of the clubhouse at Jefferson Park in 1938 reads "Lunch–Fountain." This golf course was popular with Japanese and Japanese Americans in the 1930s, many of who lived on Beacon Hill, as most housing covenants in other neighborhoods banned minorities. Jefferson Park Golf Course was the site of the Japanese Golf Association's annual tournament in 1931. (Courtesy of Seattle Municipal Archives.)

19TH HOLE. It is a long walk to the 19th hole at Jackson Park Golf Course, as seen here in 1960. Bill Tindall was the club champion in 1960 and 1961. As a 14-year-old, Tindall won the Seattle City Amateur Championship. Then, at 17, he won the US Junior Amateur Championship. Years later, a young Tiger Woods would also win this tournament. (Courtesy of Seattle Municipal Archives.)

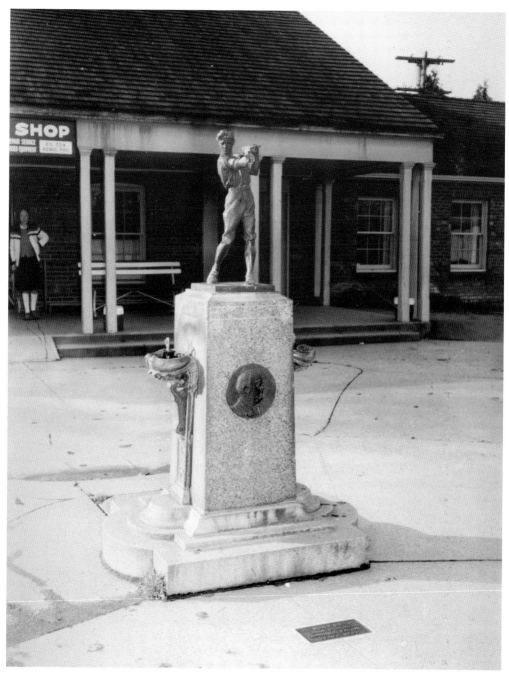

MISSING CLUB. This monument was erected in honor of Sherwood Gillespie after Jefferson Park Golf Course opened in 1915. By the time this photograph was taken in front of the clubhouse in 1959, the golfing figurine had lost his club. Gillespie, depicted in profile on the front of the monument, was considered the regional father of municipal golf. (Courtesy of Seattle Municipal Archives.)

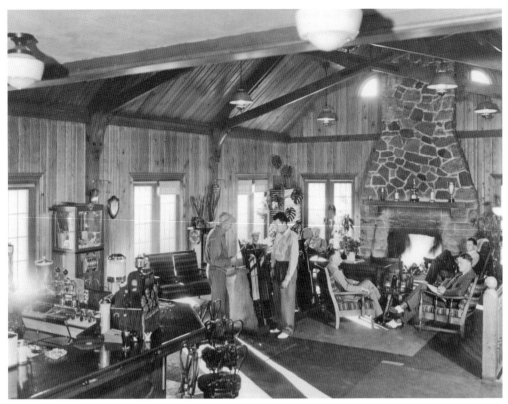

A Place to Relax. This photograph provides a peek inside the Allenmore clubhouse in 1939. Sporting a club room paneled in knotty West Coast hemlock and an opened-beamed ceiling, the clubhouse provided a cozy environment with comfortable chairs in front of a massive stone fireplace. Extravagant for the times, the clubhouse contained locker rooms and showers for both sexes. (Courtesy of Tacoma Public Library.)

Golf Course Lunch Counter, 1939. The Allenmore clubhouse, built in 1931, was designed by architects Nelson & Round. There were two bedrooms and a small apartment on the second floor. Seen here is the popular lunch counter on the main floor. (Courtesy of Tacoma Public Library.)

WEST SEATTLE CLUBHOUSE, 1946. A presidential name was considered for the municipal course before it opened in 1940, in keeping with the precedent set by the previous public courses, Jackson and Jefferson. Other names suggested were Chandler Egan Golf Course and Washington Golf Course, after the state. (Courtesy of Seattle Municipal Archives.)

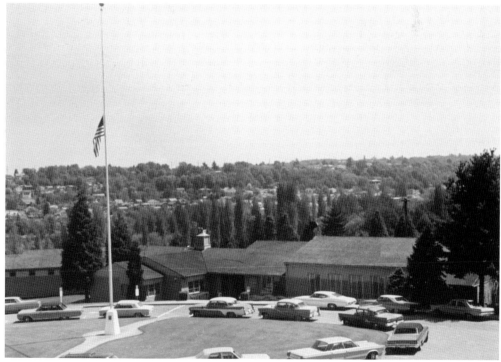

PRESIDENT EISENHOWER. The flag at West Seattle Golf Course is at half-mast, possibly in honor of former president Dwight D. Eisenhower, who died on March 28, 1969. "Ike" was an avid golfer. When he was stationed at Fort Lewis from 1940 to 1941, he played golf at the Fort Lewis Golf Course. During his eight-year presidency, he played almost 800 rounds of golf. (Courtesy of Seattle Municipal Archives.)

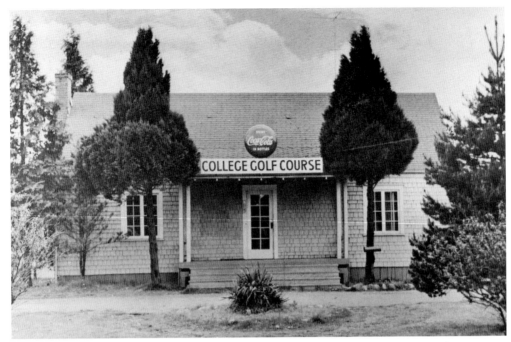

COLLEGE GOLF COURSE. The College Golf Course at Pacific Lutheran College ran an advertisement in 1948: "If You Hate Golf, Stop in Anyway and Buy a Green Death and a Candy Bar." Green fees were free to students, and the course was "open very early to very late." The clubhouse store rented and sold golf equipment. Seen at center in the below photograph is the book *Power Golf* by Ben Hogan. If this is a first edition, it is now very valuable. Autographed copies of the 1948 book were signed, "Golfingly, Ben Hogan." (Both, courtesy of Pacific Lutheran University.)

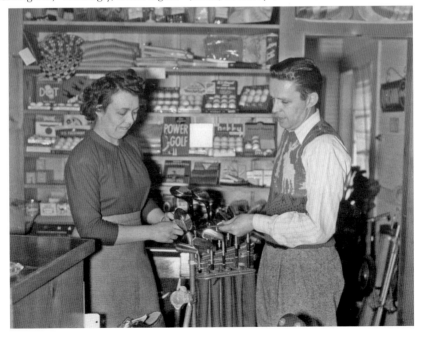

CLUBHOUSES

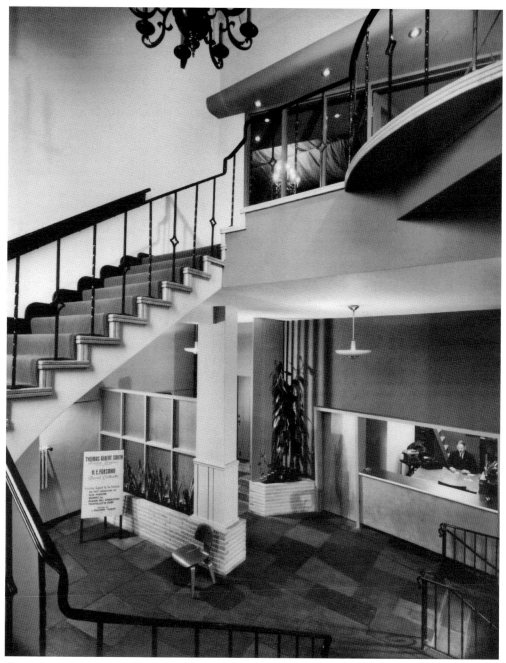

CLUBHOUSE LOBBY. Sand Point Country Club debuted its newly remodeled clubhouse in 1949. The sign at lower left lists the names of the architect, Thomas Albert Smith, general contractor, H.E. Forsman, and Bon Marche as a furnishings contributor. The man behind the counter stands to the right of a manual typewriter on a small table. The space, typical of mid-century modern style, created a fluidity between transparency and privacy. (Courtesy of Tacoma Public Library.)

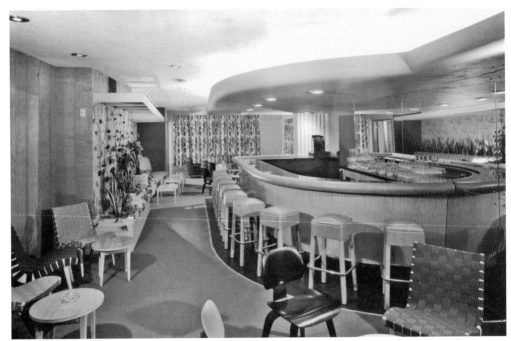

MID-CENTURY MODERN COCKTAIL LOUNGE. The clubhouse at Sand Point Country Club received a $25,000 makeover in 1949. Architect Thomas Albert Smith converted the upper floor into an up-to-date cocktail lounge, which led out to a window-enclosed terrace overlooking Lake Washington and the golf links. Design throughout the second story included floral drapes, low black and vermilion red tables, and a color scheme with muted shades of gray, brown, green, and pink. The Fairway Terrace room featured wood-sculpted chairs, clear glass ashtrays, striped and patterned upholstery, and recessed light fixtures. (Both, courtesy of Tacoma Public Library.)

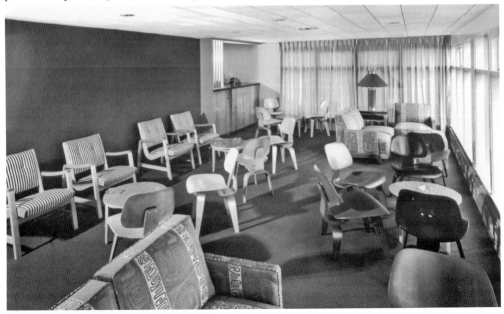

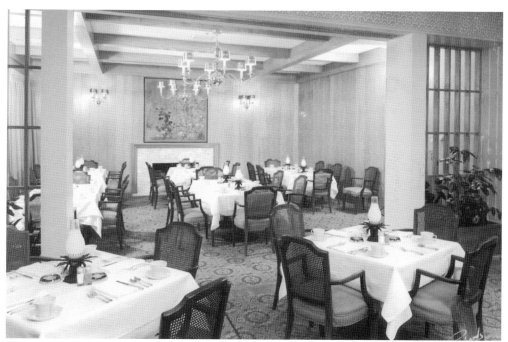

NEW TACOMA CLUBHOUSE, 1964. These photographs were taken for Weyerhaeuser Company, which provided the wood used to build the new clubhouse at Tacoma Country & Golf Club, including the hardwood floors and the wood paneling for the dining room (above) and conference room (below). Wood paneling was a prevalent wall covering of the 1960s. Another sign of the times is the requisite ashtrays adorning the tables in both rooms. The cushioned chairs in the dining room are a reddish shade, a color reflected in the rest of the decor. In the meeting room, the wood table and cabinet match the wood paneling, and the carpet is a light-teal color. (Both, courtesy of Tacoma Public Library.)

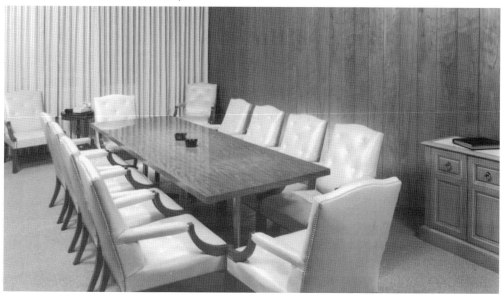

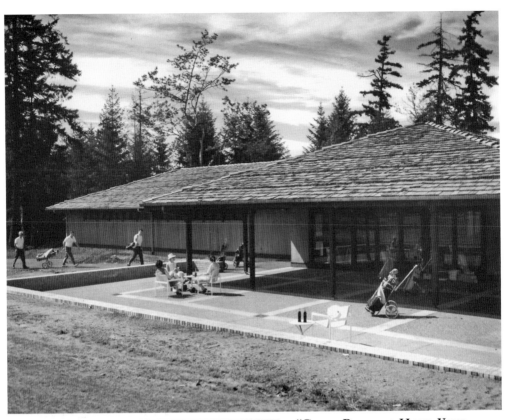

"GREAT PLACE TO HANG YOUR HAT." This slogan was featured with the below photograph in the *Tacoma News Tribune* in July 1967. The advertisement for the new Oakbrook Golf and Country Club touted the features of the Oakbrook community, including the original oaks and firs, the creek running through the woods, and beautiful new homes starting at $26,500. The private golf course, located in Lakewood, south of Tacoma, was promoted as a challenging 18-hole course surrounded by natural beauty. The $340,000 clubhouse included a pro shop, saunas, club rooms, and exercise and locker rooms. In 2012, Oakbrook opened to the public for the first time. (Both, courtesy of Tacoma Public Library.)

CLUBHOUSES

5

DIVERSITY

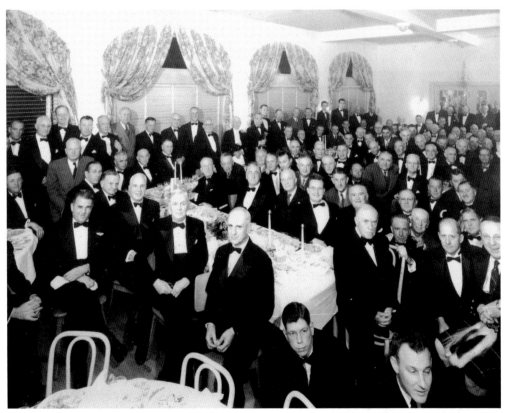

SEA OF WHITE FACES. This Tacoma Country & Golf Club photograph was taken in 1948 at a banquet celebrating its founding member, Alexander Baillie. The membership seen here is as white as it was when Baillie fostered the Scottish game of golf into Washington State 50 years earlier. In 1948, golf opportunities for minorities were limited, but a few determined players were starting to forge a path to the course. (Courtesy of Tacoma Public Library.)

TUESDAY IS LADIES' DAY. Females usually gained country club status through their husbands and fathers. The unidentified women in the above photograph are taking advantage of their weekly golfing privilege, "Ladies Day," on the last Tuesday of June 1942 at Tacoma Country & Golf Club. Below, on the following Tuesday, the female members of the club are gathered to begin preparations for the annual women's tournament. Pictured below, from left, are Mrs. Harry Cain, Mrs. Fred Dravis, Mrs. Augustus Clapp, Mrs. Henry Foss, Mrs. Harry Andrews, and Mrs. Thomas Curran. (Both, courtesy of Tacoma Public Library.)

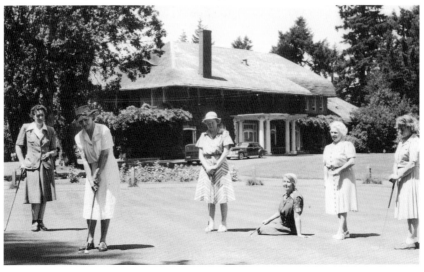

DIVERSITY

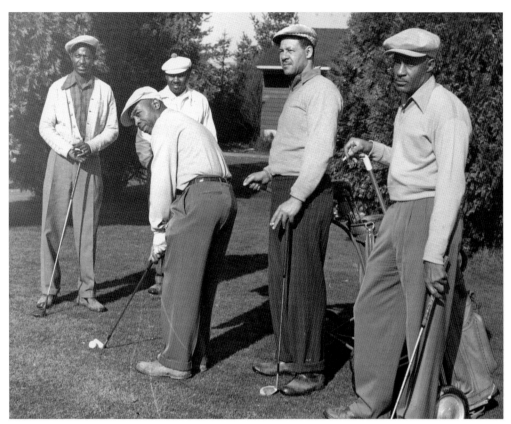

PLAYERS AT SEATTLE COURSE, 1954. The City of Seattle and Jefferson Park were sued for discrimination because African Americans were not allowed to join the Jefferson Park Golf Club. The city told the club that it could not use the park for meetings unless it integrated. To avoid this mandate, the Jefferson Park Golf Club members changed the name of their club, so that they would not have to follow this order. Jefferson Park is now one of the most diverse public golf courses. (Courtesy of University of Washington Special Collections.)

LONNIE SHIELDS. Chief locker steward at the Broadmoor Golf Club, Alonzo "Lonnie" Shields is pictured here on a Seattle golf course in an undated photograph. Shields, an early member of Fir State Golf Club, owned the Adelphi Apartments in Seattle. Fir State Golf Club, a thriving organization, is the second-oldest black golf club in the United States. (Courtesy of Black Heritage Society of Washington State.)

FIR STATE GOLF CLUB. Eligibility to play in golf tournaments required membership in a recognized club. Such clubs did not accept minorities and, as a result, minorities could not compete in tournaments. They were allowed to play on municipal courses, but they could not join their clubs. Fir State Golf Club was started by 15 minority golfers to afford golf opportunities to everyone. Early members included Henderson Quinn, Lonnie Shields, Wilbert Ponder, Fitzgerald Beaver, Ulysses "Jabo" Ward, John Shannon, Hayward Bascomb, Charles Ethridge, Ben Beasley, Pat Francis, Lucius Dean, Robert Wright, and Madeline Wright. A documentary on Fir State, *Out of the Rough*, is scheduled for release in 2016. Fir State Golf Club, shown here, is located near Jefferson Park Golf Course and has an active Junior Golf Foundation. (Both, author's collection.)

THE WHITE HOUSE			THE DAILY DIARY OF PRESIDENT GERALD R. FORD	

PLACE DAY BEGAN	DATE (Mo., Day, Yr.)
THE WHITE HOUSE WASHINGTON, D.C.	AUGUST 10, 1976
	TIME DAY
	6:56 p.m. TUESDAY

TIME		PHONE P=Placed R=Rec'd	ACTIVITY
In	Out		
6:56			The President went to the swimming pool.
7:16			The President returned to the Oval Office.
7:17			The President returned to the South Grounds of the White House.
7:17	7:39		The President motored from the South Grounds to the residence of Mr. and Mrs. John J. "Jack" Pohanka, 8810 Burning Tree Road, Bethesda, Maryland. Mr. Pohanka is President of Pohanka Oldsmobile, Incorporated, Marlow Heights, Maryland.
7:39	9:50		The President attended a cocktail reception and dinner honoring players in the 58th Professional Golfers Association (PGA) Tournament. For a list of attendees, see APPENDIX "D."
7:39			The President was greeted by: Mr. Pohanka Mrs. Pohanka Lee Elder, professional golfer and Co-host Mrs. Lee (Rose) Elder, manager for her husband
7:40			The Presidential party went inside the residence. The President greeted guests.
8:05			The President was presented with a medallion designating him Honorary Chairman of the 58th PGA Tournament by tournament Chairman Frank J. Murphy, Jr.
8:06	8:09		The President addressed approximately 120 guests including PGA golfers and their spouses, automobile dealers and personal friends of Mr. and Mrs. Pohanka and Mr. and Mrs. Elder. The Presidential party had dinner.
8:44		R	The President was telephoned by his daughter, Susan. The call was not completed.
9:38		R	The President was telephoned by Rev. Mr. Zeoli. The call was not completed.

GPO : 1974 OL—555—863

Page 4 of 5 Page(s).

FROM FORT LEWIS TO THE WHITE HOUSE. Drafted in 1959, Robert Lee Elder, known as Lee, was stationed at Fort Lewis under Col. John Gleaster, an ardent linksman. Gleaster saw to it that Elder's assignments included lots of golf. In 1960, the *Seattle Times* commented on Elder's "red-hot Fort Lewis golf team," noting that Elder and two teammates each carded 67, five under par. He turned pro in 1961 and followed a circuitous route that culminated in Lee Elder becoming the first African American to play in The Masters, in 1975. A year later, he golfed with Pres. Gerald R. Ford and was a guest at the White House. Shown here is part of Ford's schedule for August 10, 1976, the day of that visit. (Courtesy of the Gerald R. Ford Presidential Library and Museum.)

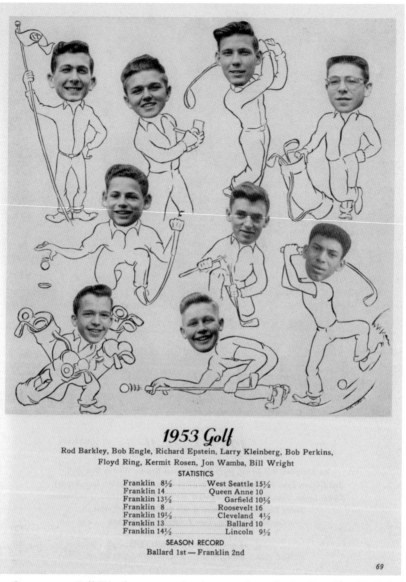

1953 Golf

Rod Barkley, Bob Engle, Richard Epstein, Larry Kleinberg, Bob Perkins,
Floyd Ring, Kermit Rosen, Jon Wamba, Bill Wright

STATISTICS

Franklin 8½	West Seattle 15½
Franklin 14	Queen Anne 10
Franklin 13½	Garfield 10½
Franklin 8	Roosevelt 16
Franklin 19½	Cleveland 4½
Franklin 13	Ballard 10
Franklin 14½	Lincoln 9½

SEASON RECORD
Ballard 1st — Franklin 2nd

69

NATIONAL CHAMPION. Bill Wright, pictured at lower right with the Franklin High School golf team in 1953, learned to play golf at the Jefferson Park Course, but he preferred basketball, and he was good at it. After graduation, Wright wanted to play for the University of Washington, but it was not ready to integrate its basketball team. So, he played basketball for Western Washington State College and joined its golf squad. While still a student at Western, Wright entered the amateur links competition through Portland's Eastmoreland Course, because his color disqualified him from entering in association with local golf courses. Wright then traveled to Denver and competed in the amateur event at Wellshire Golf Course, and won, becoming the 1959 National Public Links Champion. Bill Wright was the first black player to win a USGA national title. Wright's parents, Robert and Madeline Wright, were founding members of Fir State Golf Club. (Courtesy of Franklin High School.)

CHINESE GOLF CLUB. Formed in 1951, Seattle Chinese Golf Club later changed its name to Seattle Cascade Golf Club. The club is still active and now belongs to the Federation of Chinese Golf Clubs. The founding members were Hing Chinn, Mar Wah, Yuen Chinn, Frank Mar, Lucas Chinn, Alex Jue, Art Louie, William Wong, Ed Lew, George Louie, Wilber Wong, Dr. Henry "Butch" Luke, Harry Eng, Russell Luke, William Eng, and Morton Woo. William Eng aced the sixth hole at Allenmore Golf Course on May 17, 1954. (Courtesy of Wing Luke Museum.)

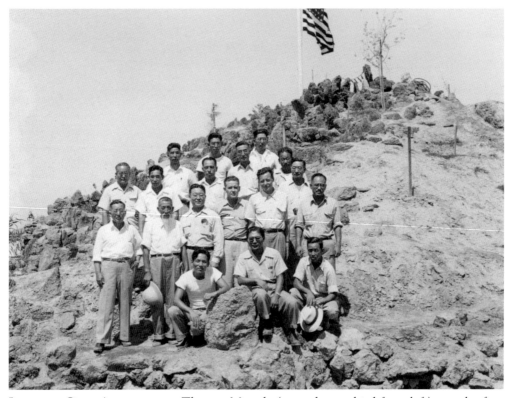

JAPANESE GOLF ASSOCIATION. Thomas Masuda (second row, third from left) was the first president of the Pacific Northwest Japanese Golf Association, founded in 1936. Members conducted tournaments in Washington, Oregon, and Canada. This 1943 photograph was taken while he was interned at the Poston War Relocation Center in Arizona. Masuda, a Seattle attorney, had been acquitted on federal charges that he was an agent of the Japanese government. (Courtesy of Bancroft Library, University of California, Berkeley.)

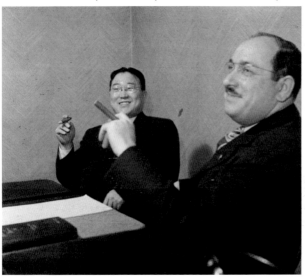

THOMAS SHINAO MASUDA, 1945. After American-born Thomas Masuda (left) was released from the Poston internment camp in 1944, he was not allowed to return to the West Coast. He settled in Chicago and joined a law firm with Oscar M. Nudelman (right). Masuda later started his own highly successful firm and continued being a vigorous community activist and golfer. (Courtesy of Bancroft Library, University of California, Berkeley.)

DIVERSITY

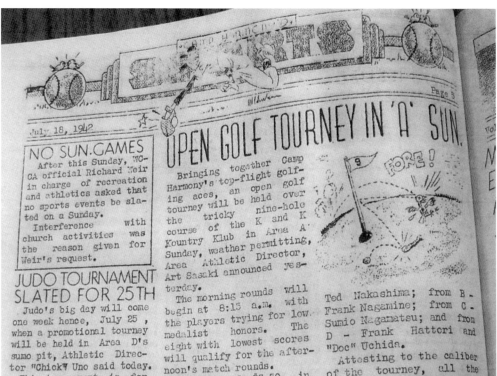

July 18, 1942

NO SUN GAMES

After this Sunday, YC-CA official Richard Weir in charge of recreation and athletics asked that no sports events be slated on a Sunday.

Interference with church activities was the reason given for Weir's request.

JUDO TOURNAMENT SLATED FOR 25TH

Judo's big day will come one week hence, July 25, when a promotional tourney will be held in Area D's sumo pit, Athletic Director "Chick" Uno said today.

This tournament is for those under sho-dan who will have a chance to advance themselves.

Also on the program will be special matches bringing together the senior division matmen.

With the exception, possibly of C, which has limited athletic facilities, each area will have a chance to sponsor an inter-area tourney.

OPEN GOLF TOURNEY IN 'A' SUN

Bringing together Camp Harmony's top-flight golfing aces, an open golf tourney will be held over the tricky nine-hole course of the K and K Kountry Klub in Area A Sunday, weather permitting, Area Athletic Director, Art Sasaki announced yesterday.

The morning rounds will begin at 8:15 a.m. with the players trying for low medalist honors. The eight with lowest scores will qualify for the afternoon's match rounds.

A prize of $3.50 in script will be given the champion while the low medalist will garner a $1 coupon book. Each entrant will be assessed a 25 cent entry fee.

Among the top-notch fairway performers who are entered in this unique tournament are the following: from A - Sparky Kono, the Kashiwagi brothers, and

Ted Nakashima; from B - Frank Nagamine; from C - Sumio Naganatsu; and from D - Frank Hattori and "Doc" Uchida.

Attesting to the caliber of the tourney, all the golfers mentioned above were formerly 10 or under handicappers during their pre-evacuation days.

The entry list follows:

A - Lake Hoshino, Sparky Kono, Tats Hayasaka, Johnson Shimizu, Mits Kashiwagi, George Kashiwagi, Mrs. and Mrs. Yashima Mrs. Chiba, Ted Nakashima, Kawaguchi and Bill Minbu.

B - Dick Nomoda, Terumasa Furuta, Yone Ota, Takeo Furumoto, Kenji Yoshino, Monroe Bonyu, Nobi Nakaga-

'SUMO-TORIS' FROM 'D' SPARKLE

Sweeping 10 matches dur- "Boefo" Amabe of A. Mits

GOLF IN RELOCATION CAMP. Japanese Americans were housed at the Puyallup Assembly Center for several months in 1942 while they waited for their internment assignments. The center became known as Camp Harmony, and the residents printed a newsletter. This page from the July 18, 1942, edition has an article about a golf tournament the internees had organized. It was held in Area A on a nine-hole course at the "K and K Kountry Klub." Golfers competing from Area D were as follows: Dr. Uchida, Dr. Nakamura, T. Hibiya, Tanabe, Y. Harada, Henry Miura, T. Nakamura, T. Kinomoto, T. Masuda, F. Hattori, K. Iki, C. Hattori, and S. Uchida. Previous issues tell of the miniature-golf course, nicknamed "The Haba-Haba Country Club," and mention Jefferson Park "par-busters" Sparky Kono, Johnson Shimizu, Shang Kashiwagi, and Mits Kashiwagi. (Courtesy of Densho Digital Archive.)

IMPRISONED APART. University of Washington instructor Iwao Matsushita took this photograph of a line of golf bags. The book *Imprisoned Apart* by Louis Fiset contains correspondence between Matsushita and his wife, Hanaye, while they were in separate internment camps. Matsushita wrote, "I saw a few children ski on the golf course outside the enclosure and I dreamed that I skied on Mount Rainier." After receiving a package from his wife, he wrote, "My Dear Wife. Thank you for the old golf shoes. Your Husband." (Courtesy of University of Washington Special Collections.)

DIVERSITY

VARSITY GOLF SQUAD MEMBER.
Showing off his putting skills in the
early 1950s is Ervin Furukawa, a player
on the University of Washington
varsity golf team. Furukawa made
a hole-in-one at Jackson Park Golf
Course in November 1953. Using a
brassie, he aced the 194-yard 12th hole.
(Courtesy of Wing Luke Museum.)

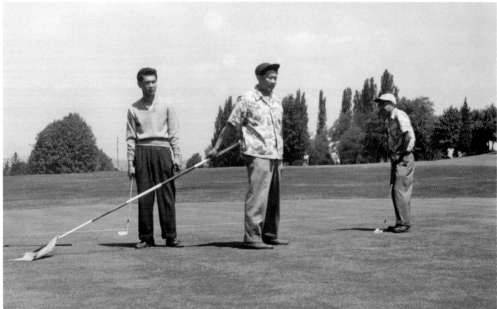

NVC GOLF TOURNAMENT. Tom Okazaki (left), Sam Saiki (center), and an unidentified man
take part in a Nisei Veteran's Committee Golf Tournament in this undated photograph. During
World War II, Okazaki served in the US Army's 442nd Regimental Combat Team, and Saiki was
interned at the Minidoka relocation camp. In 1947, Saiki joined the US Army and worked as an
interpreter in Japan. (Courtesy of Wing Luke Museum.)

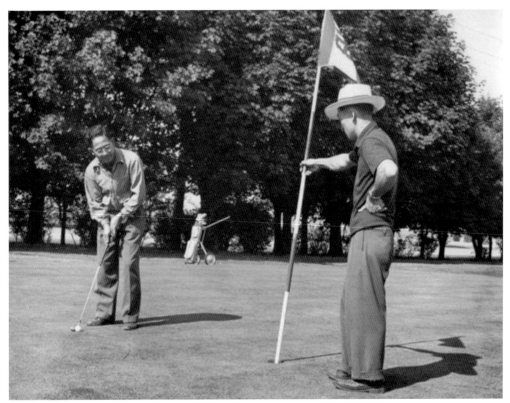

NISEI GOLF. After World War II, Japanese Americans who had served in the US military were not allowed to join the American Legion or the Veterans of Foreign Wars. In response to this, the Nisei Veterans Committee was formed on March 25, 1946. The communal club was soon holding golf tournaments, as seen here. The below photograph was taken in 1952. The club is still active today, and its current mission is "to preserve and honor Japanese American legacies and to provide community programs that meet the educational, cultural, and social needs of the broader community." The club's legacy of NVC golf tournaments has continued as well. (Above, courtesy of Wing Luke Museum; below, courtesy of University of Washington Special Collections.)

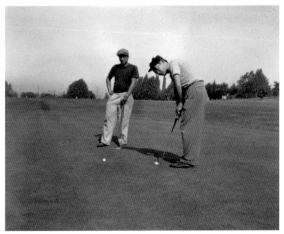

INTRIGUING CHARACTERS

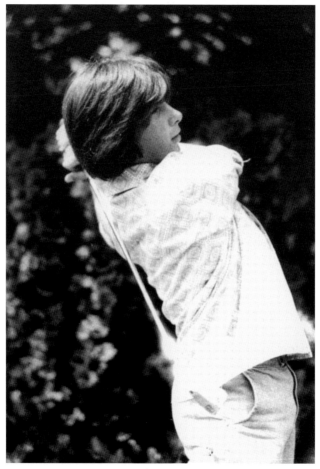

FRED COUPLES. Future professional golfer Fred Couples demonstrates his characteristic swing as a member of the 1976 golf team at Seattle's O'Dea High School. On August 4, 1971, the *Seattle Times* reported that 11-year-old Fred Couples was in first place in the second round of the junior golf tournament at West Seattle Golf Course. In his Tiny Tad division, Couples would end up with 257, followed by Jim Campbell's 277. At 17, Couples headed to the University of Houston on a golf scholarship. He turned pro in 1980 and earned the nickname "Boom Boom," for his long, powerful drives. He amassed 15 PGA Tour event wins, 11 Champions Tour wins, and played on numerous Ryder Cup and President Cup teams. His laid-back temperament made him a favorite of the media, fans, and other players. In 2013, "Boom Boom" was inducted into the World Golf Hall of Fame. (Courtesy of O'Dea High School.)

MARJORIE JEFFRIES SHANAMAN, C. 1920.
The Shanaman Sports Museum, named in honor of Fred and Marjorie Shanaman Sr., is attached to the Tacoma Dome. The museum's website states that Marjorie Shanaman, a Washington State women's champion, held a 2 handicap when she was 18 years old. A Tacoma Country & Golf Club member, Fred Shanaman Sr. was a community leader and member of the Tacoma Athletic Commission. (Courtesy of Shanaman Sports Museum.)

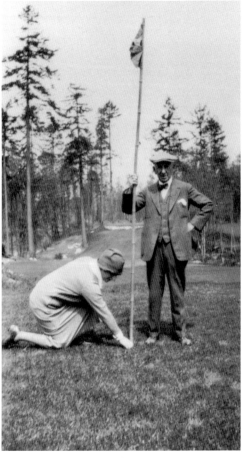

SAMUEL STERN, 1920S. King County Superior Court judge Stern and his wife, Blanche Newberger, lived at the Sorrento Hotel in downtown Seattle. When he turned 80 in 1935, he became the oldest member of the Washington State Senior Golf Association. His philosophy was "drink a little, eat less, and help those less fortunate." (Courtesy of University of Washington Special Collections.)

INTRIGUING CHARACTERS

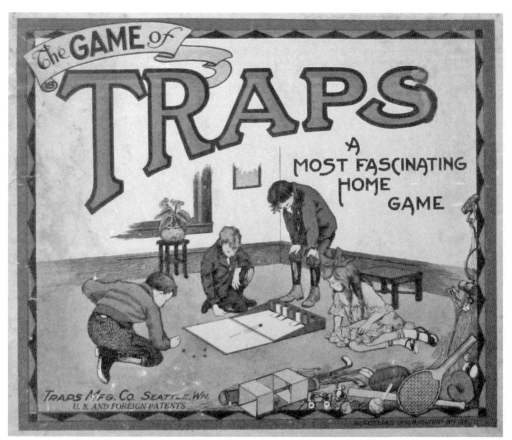

GAME OF TRAPS. Unable to afford gifts, a father created a golf-themed marble game for his children. He sold the rights to Alfred S. Witter, a photographer, and James W. Wheeler, a major real estate player in Seattle's development. As a visionary teenager, Wheeler purchased 40-acre lots at a pittance on his way to becoming a millionaire. In 1921, Witter produced The Game of Traps in his Summit Avenue North home, employing an assembly line of neighborhood adults and children, eventually producing 500 games a day. The marbles, made in West Virginia, were shipped to Seattle through the Panama Canal. By 1927, the game was a national hit and was sold in New Zealand, South Africa, and Australia. (Both, author's collection.)

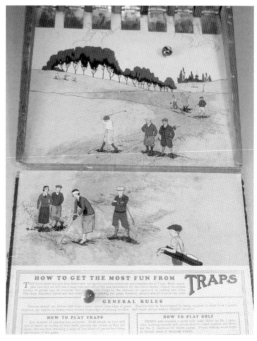

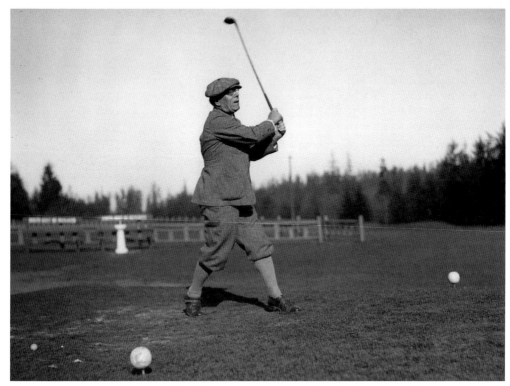

ALBERT S. KERRY, 1925. Canadian-born A.S. Kerry started at the bottom, working at a sawmill. He eventually used a keen business sense to became one of the West's top lumbermen. He served as president of Pacific Northwest Golf Association and was instrumental in bringing the Western Amateur Championship to Seattle in 1927. He was a member of both the Rainier and Seattle Country Clubs. He donated land on Queen Anne Hill that became Kerry Park. (Courtesy of the Museum of History and Industry.)

HONEST GOLFER. In 1941, Tacoma's Howard Olson received the A.S. Kerry Sportsman Award for calling a two-shot penalty on himself during a 1940 tournament in Detroit. On the final hole of the qualifying round, after capably hitting a ball out of the rough, Olson discovered that it was not his ball. Upon confessing, he went from a 4 to a 6 for the hole, which forced him into a playoff round to get into the match. (Courtesy of Shanaman Sports Museum.)

INTRIGUING CHARACTERS

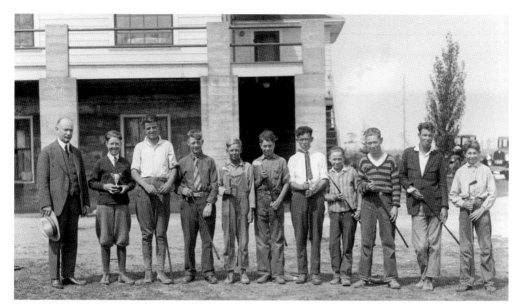

CADDIE COMPETITION. Several caddies pose in front of the new clubhouse at Fircrest Golf Course after participating in the caddie tourney on August 27, 1926. The boy wearing knickers and holding a trophy might be Jack Walters, who grew up to become a southpaw legend and president of the Fircrest Golf Club. (Courtesy of Washington State Historical Society.)

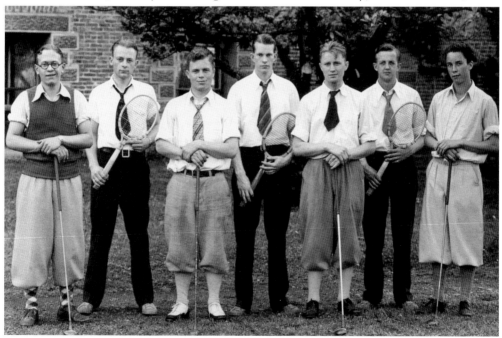

GLADIATOR GOLF TEAM. The Pacific Lutheran College golf and tennis teams appear together in the 1931 *Saga* yearbook. They were the first golf squad to represent the school. Holding golf sticks are, from left, Cecil Scott, Ben Palo, Herman Anderson, and Ray Hiderlie. They played on Parkland Golf Course, which later became part of the college. (Courtesy of Pacific Lutheran University.)

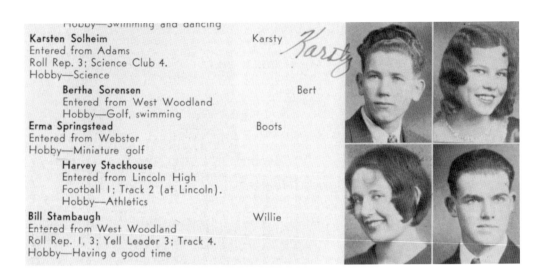

Hobby—swimming and dancing

Karsten Solheim Karsty
Entered from Adams
Roll Rep. 3; Science Club 4.
Hobby—Science

 Bertha Sorensen Bert
 Entered from West Woodland
 Hobby—Golf, swimming

Erma Springstead Boots
Entered from Webster
Hobby—Miniature golf

 Harvey Stackhouse
 Entered from Lincoln High
 Football 1; Track 2 (at Lincoln).
 Hobby—Athletics

Bill Stambaugh Willie
Entered from West Woodland
Roll Rep. 1, 3; Yell Leader 3; Track 4.
Hobby—Having a good time

PING. A 1931 graduate of Seattle's Ballard High School, Karsten Solheim was a problem-solver. On his first golf outing at age 42, he noticed that the putter was not designed for optimal performance. He began reshaping the club, moving the shaft from the end toward the center of the head. The Norwegian-born engineer who honed his skills in the Ballard High Science Club (below, back row, third from right) continued to improve other golf clubs. Thus was born the innovative PING brand. Karsten Manufacturing was an international sensation, making Solheim worth more than $500 million. Karsten Solheim gave back; he was the catalyst behind the Solheim Cup, a tournament between US and European women. Arizona State and Oklahoma State Universities have golf courses that bear his name. (Courtesy of Ballard High School.)

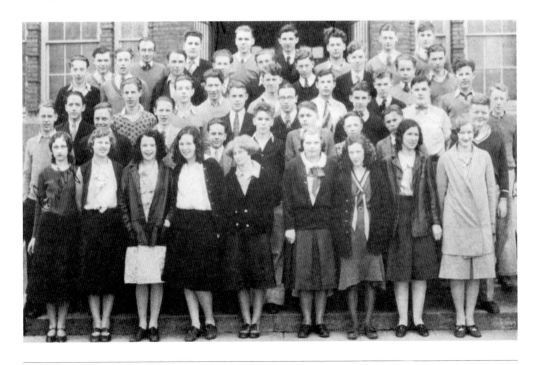

Babe Didrikson Zaharias, c. 1934. Still a beginning golfer, Mildred "Babe" Zaharias demonstrated her powerful swing in Tacoma (right). Zaharias was considered one of the best female athletes in the world in multiple sports. She won gold medals in track at the 1932 Olympics and won the US Women's Open three times. Shown below are, from left, Eda Squire, Ruth Busch, Zaharias, and Helen O'Brien. Eda Squire, a *Tacoma Times* journalist, wrote "Fair on the Fairway," believed to be the first golf column about women. Busch was a three-time Tacoma Women's Golf Association champion. (Both, courtesy of Tacoma Public Library.)

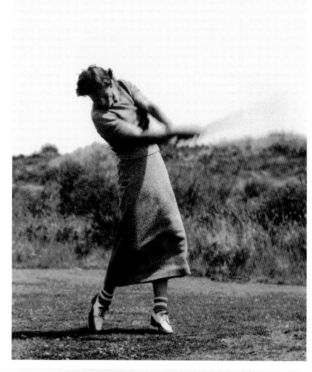

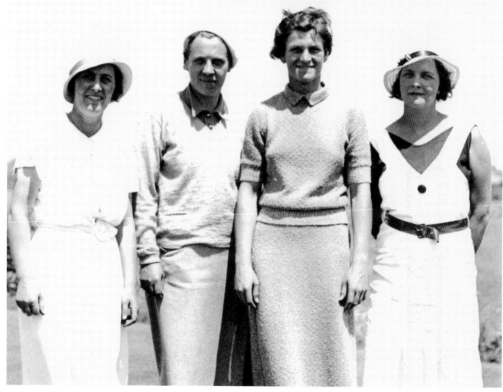

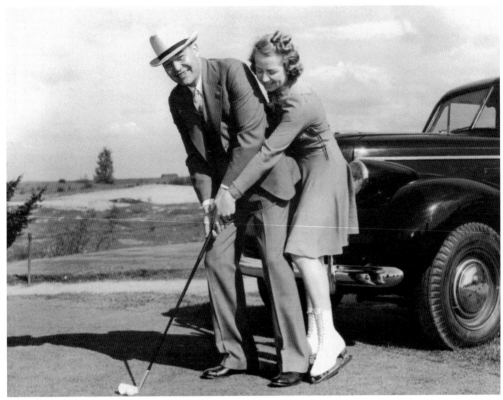

WIN A BUICK. Ice-skater Dora Mae Rice "helps" Tacoma businessman Ted E. Faulk with his swing for a promotion of the hole-in-one tournament at the Allenmore Golf Course in 1939. Each participant would get 100 tries. The new Buick seen behind Rice and Faulk was the prize. (Courtesy of Tacoma Public Library.)

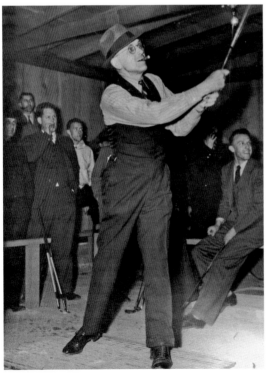

INDOOR DRIVING RANGE. Melvin G. Tennent, Tacoma's former mayor, tries his luck at the Allenmore Golf Course's hole-in-one contest in 1939. Though he was hailed the "King of Aces" for his previous eight holes-in-one, this was not his year. The gentleman to the left, smoking a cigar, is John H. Anderson, a future Tacoma mayor. (Courtesy of Tacoma Public Library.)

INTRIGUING CHARACTERS

COUNTRY CLUB CADDIES, 1941. These weary-looking caddies worked hard on a hot day during the 21st annual Northwest Lumbermen's Golf Tournament, held at the Tacoma Country & Golf Club. Robert Studebaker of Shelton won the match with a net 69. Tacoma's Corydon Wagner, a future West Coast board member of the US Golf Association, came in second. (Courtesy of Tacoma Public Library.)

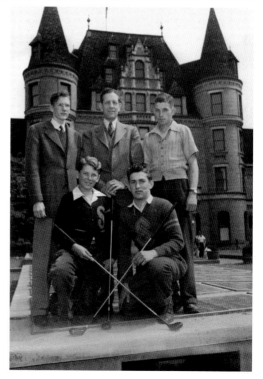

STADIUM HIGH SCHOOL. The Stadium golf team poses here in 1942. From left are (first row) Roland Hoar and Oscar "Ockie" Eliason; (second row) Elmer Nelson, coach Harry Swarm, and Sam York. Team member Chet Brown is not pictured. Eliason went on to become a two-time winner of the Northwest Open. This Stadium High Tiger team was the Cross-State League champions. (Courtesy of Tacoma Public Library.)

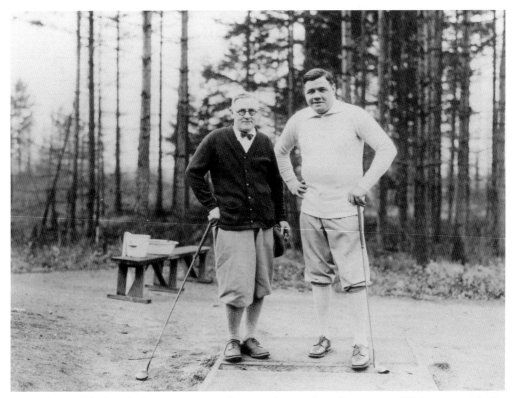

BABE RUTH. The baseball great, visiting Tacoma during the off-season in 1926, poses with Dr. William B. Burns at the Fircrest Golf Club. George Herman Ruth (right) was an avid amateur golfer, arguably the most famous golfer of his time. Dr. Burns, a Tacoma dentist, had been a pitcher for the New York Giants in 1898. (Courtesy of Shanaman Sports Museum.)

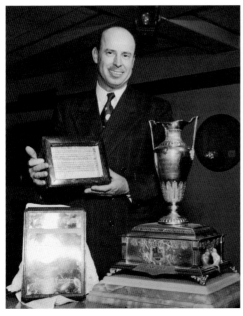

CHUCK CONGDON. Voted Sportsman of the Year by the Tacoma Athletic Commission in 1949, Congdon was the pro at Tacoma Country & Golf Club. He was the third recipient of the award. The previous year, Congdon won the Canadian Open. The ceremony took place at a stag banquet at the Top of the Ocean on February 3, 1949. (Courtesy of Tacoma Public Library.)

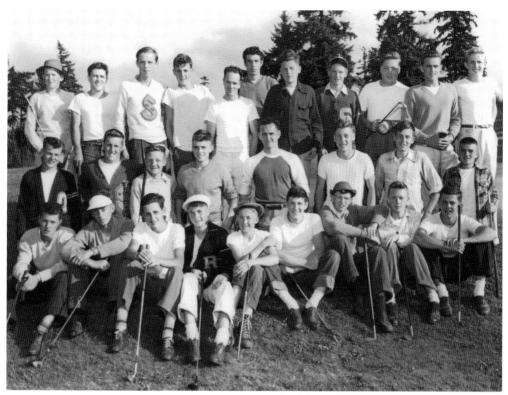

FIRCREST CADDIES. Extra caddies were recruited for the 1946 Pacific Northwest Golf Association Championship Tournament. Fircrest erected three caddie stations around the course to accommodate the event. Competitors paid $5 to enter the match. The handicap limit was 9 strokes for men and 24 strokes for women. (Courtesy of Tacoma Public Library.)

FIRCREST GOLF COURSE, JULY 1946. Jerry Driscoll (left) captured the Tacoma Jubilee golf title at the Northwest Prep Championship Tournament by one stroke, placing Bruce Andreasen (center) in the second spot. Dick Nicholson (right) followed up a stroke behind Andreasen, for third place. (Courtesy of Tacoma Public Library.)

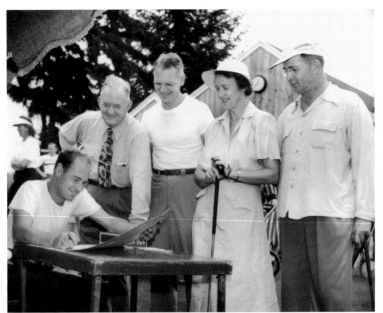

TWO-BALL FOURSOMES. In August 1948, Fircrest Golf Club hosted the annual mixed two-ball foursomes. Frank Newell, the golf pro at Fircrest, is shown registering participants. The golfing event was followed with cocktails, dinner, and a movie. (Courtesy of Tacoma Public Library.)

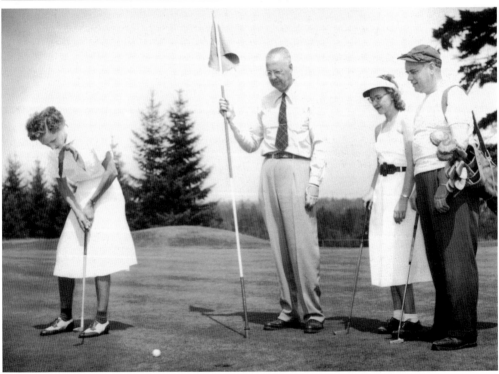

SHIRLEY FOPP, 1948. Donald T. McDonald holds the flag while his daughter Shirley Fopp putts. They competed in the mixed two-ball foursomes tournament at Fircrest Golf Course. An all-around athlete, Fopp won the Women's National Ski Championship in 1942 and the Washington State Women's Public Links Championship seven times. In the 1941 movie *Two-Faced Woman*, she doubled for Greta Garbo. (Courtesy of Tacoma Public Library.)

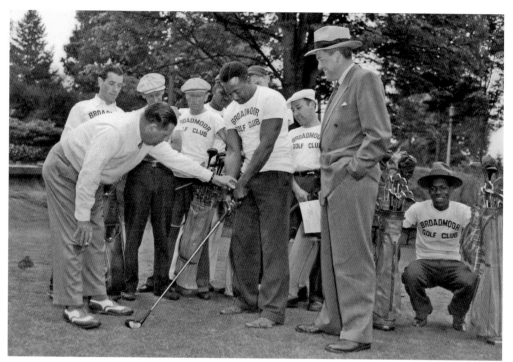

BROADMOOR CADDIES. Head golf professional George Howard checks a caddie's grip in 1949 at Seattle's Broadmoor Golf Course, which opened in 1927. On June 12, 1949, the following help-wanted advertisement appeared in the classified section of the *Seattle Times*: "Wanted 50 boys for caddies. Training program starts this week. Best opportunity for boys to make money during the summer. Call Broadmoor Golf shop EAst 5155." (Courtesy of Museum of History and Industry.)

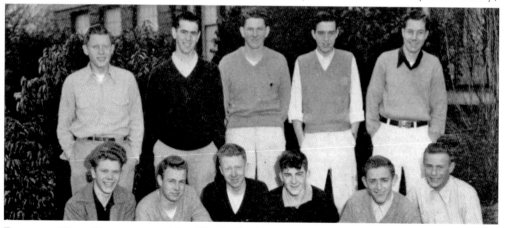

BALLARD HIGH YEARBOOK, 1950. The Ballard golf squad, pictured here, are, from left (first row) Franklin Johnson, Dick Ottoson, Jerry Fehr, Sid Peters, Stan Johanson, and Ken Johansen; (second row) Wayne Lingenbrink, Gordon Rootvik, John Mountain, Wally Goleeke, and Don Wayland. Fehr went on to play golf for Yale University and was captain of the team. After college and a stint in the Navy, he continued to play as a leading amateur, winning the 1961 Washington State Open. (Courtesy of Ballard High School.)

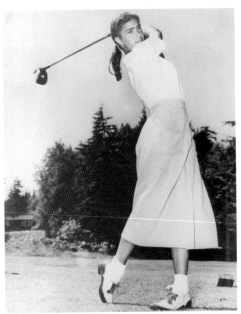

GLENDALE COUNTRY CLUB, 1949. Future Curtis Cup team member Pat Lesser was a teenager when this photograph was taken at Glendale Country Club in south Seattle. The country club started out in the 1920s as the Washington Golf and Country Club; the name was changed to Glendale a year later. The establishment moved to the east side in the mid-1950s; Glendale Country Club is still located at 13440 Main Street in Bellevue. The site of its former Seattle course became the Glen Acres Country Club. (Courtesy of Shanaman Sports Museum.)

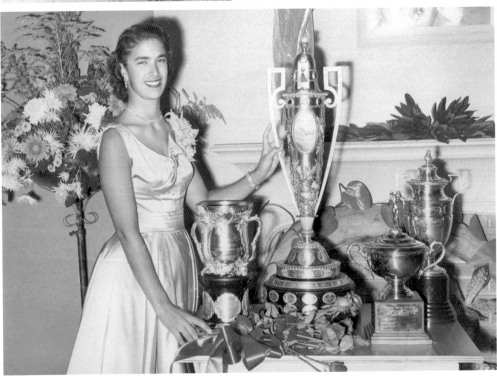

AMATEUR CHAMPION, 1955. Pat Lesser poses next to her USGA Western Amateur Champion trophy. That year, she also won the US Women's Amateur; two years earlier, she won the National Collegiate Championship. She played on the men's golf team at Seattle University with her future husband, Dr. John Harbottle, also a Northwest golf legend. Their son John Harbottle III was a much-admired golf architect. (Courtesy of Shanaman Sports Museum.)

INTRIGUING CHARACTERS

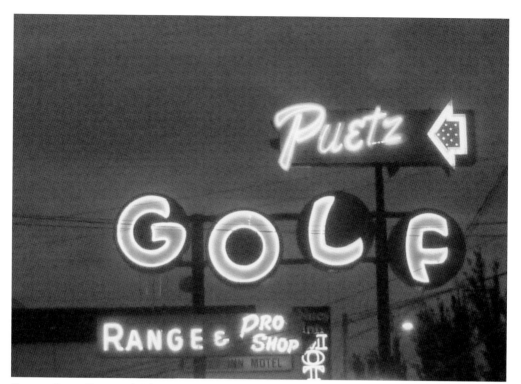

PUETZ GOLF. Peter and Alvin Puetz started out as scrappy Seattle Golf Club caddies and evolved into skillful golfers with a passion for the game. The brothers channeled this enthusiasm into the north Seattle driving range they opened in 1945. To keep the range affordable, they eventually started selling low-priced golf products, becoming one of the first discount golf stores in the country. Later, they added a miniature-golf course, seen at right. With more locations, it is now known as Puetz Golf Superstores. The iconic Puetz Golf Range sign (above) is still located at the Aurora Avenue location. (Above, author's collection; right, courtesy of Seattle Municipal Archives.)

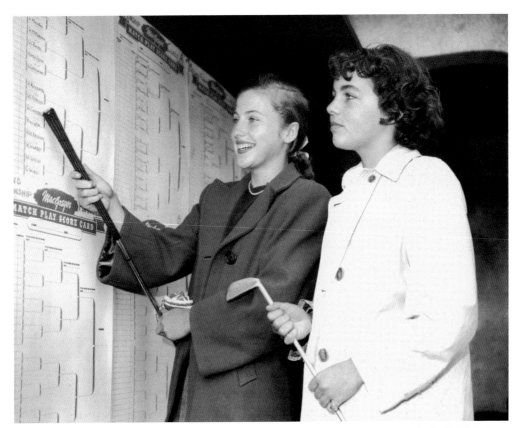

JUNIOR WEEK. Once a year, the younger set took over the Tacoma Country & Golf Club for a week of golf, tennis, and summer activities. The first Junior Week was held in August 1911. It was so successful that other clubs adopted the tradition. Above, two participants inspect the score sheet for the upcoming tournament in July 1948. Below, a group of adolescents gets ready for the Junior Week golf competition on July 27, 1949. The young members in charge of the activities that week were Paul Smith, Dana Hunter, Lawrence Ghilarducci, Jean Link, and Peggy Orr. Dana Hunter was the son of Charles D. Hunter Jr., who won the Tacoma city championship 10 times between 1931 and 1945. (Both, courtesy of Tacoma Public Library.)

INTRIGUING CHARACTERS

Capt. D. Lingenbrink

Resting? No, just looking the ground over before putting.

Crew Tees Off, Swamps Opposing Squads

GOLF—An early season loss put a stop to title hopes of the Beavers' divot diggers in "52". But as the season went on they captured all their remaining games to take a tie with Roosevelt for first place honors. With six returning lettermen, including Dale Lingenbrink, All-City Individual Champ, Ballard will be hard to beat in "53". The scores of the matches are: (Ballard first) Garfield 19-5, Cleveland 23½-½, Franklin 17-7, Roosevelt 8½-15½, West Seattle 20½-7, Lincoln 12½-11½, and Queen Anne 24-0. Adviser: Coach Elmore Oistad.

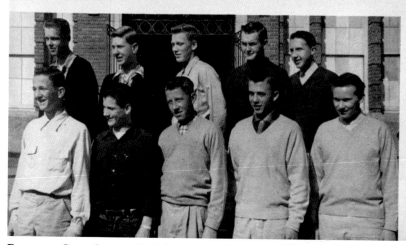

GOLF TEAM—Row 1: Smithson, Holfeldt, D. Bies, Blendheim, Cowell. Row 2: Nelson, Swanson, Lingenbrink, Connolly, K. Bies.

69

BALLARD GOLF SQUAD. Dale Lingenbrink (top, left), captain of the Ballard Beavers golf team, received a golf scholarship to Seattle University. In 1958, he shot an astounding 64 at Inglewood Golf Club in Kenmore, which was 9 under par. Inglewood was Seattle University's home course. Among the golfers shown at the bottom of the page, taken from Ballard High School's annual, is future Pacific Northwest PGA Hall of Fame member Don Bies (center, front). (Courtesy of Ballard High School.)

GOLF IN SEATTLE AND TACOMA

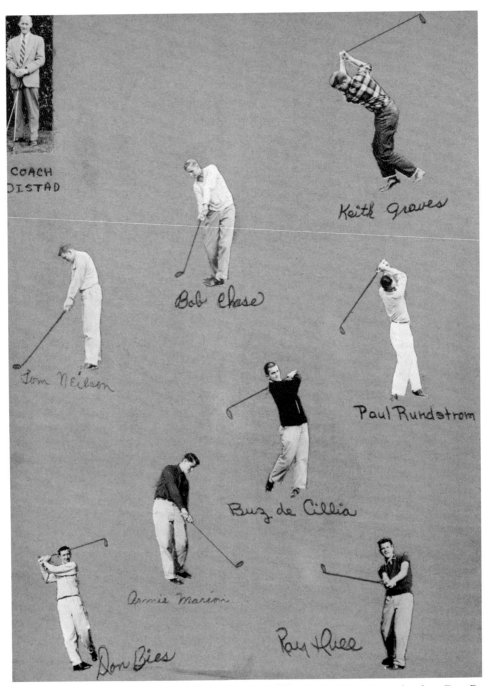

COACH
DISTAD

Keith Graves

Bob Chase

Tom Neilson

Paul Rundstrom

Buz de Cillia

Armie Marion

Don Bies

Ray Klee

DON BIES. Pictured at lower left in the 1955 *Shingle*, Ballard High School's yearbook, is Don Bies, who played on the Ballard Beavers golf team in the mid-1950s. Bies turned pro in 1957 and was inducted into the Pacific Northwest PGA Hall of Fame in 1994. He won the 1975 Sammy Davis Jr. Greater Hartford Open. He really hit his stride after his 50th birthday, when he joined the Senior PGA Tour (now known as the Champions Tour) and won seven tournaments. (Courtesy of Ballard High School.)

INTRIGUING CHARACTERS

Northwest Left-Handed Golf Association. Above, Jack and Jeanne Walters (center) celebrate Jack Walters Night in 1953. Jack had just won the National Left-Handed Golf Championship. Jeanne Walters also excelled in the sport, and the Walters were the first husband and wife to win the men's and women's Tacoma City Amateur Championship. Below are participants of the 1953 Northwest Left-Handed Golf Association Tournament. Art Scarpello was the 1952 Northwest southpaw champion, but Walters took him out by three strokes in 1953. (Both, courtesy of Tacoma Public Library.)

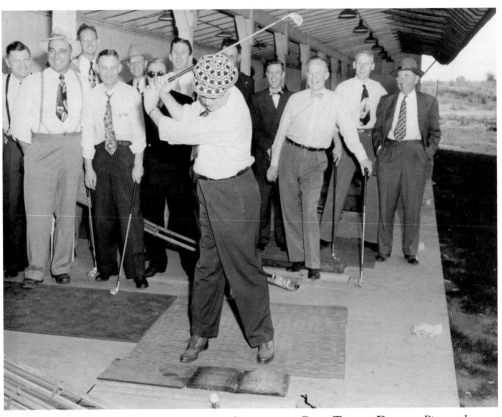

Nov. 21, 1950 B. A. HOGEBERG 2,530,698
GOLF BALL TEEING MACHINE

Filed Oct. 1, 1947 2 Sheets-Sheet 2

INVENTOR.
BART A. HOGEBERG
BY
ATTORNEYS

AUTOMATIC GOLF TEEING DEVICE. Pictured at his driving range, Bart Hogeberg demonstrates his invention, the Golf Ball Teeing Machine. During World War II, Hogeberg was a member of the Naval Cadet Selection Board's golf team, part of the Service Golf League. His team enjoyed a 14-game winning streak. After the war, Hogeberg's passion for the sport led him to open the 38th Street Driving Range in Tacoma, where he taught golf and worked on his inventions, including the Golf Ball Teeing Machine (shown in the US Patent at left.) (Above, courtesy of Shanaman Sports Museum; left, courtesy of United States Patent Office.)

SAM ALLEN, 1955. The cofounder of Allenmore Golf Course, which opened in 1931, Sam Allen was honored with a monument from Allenmore Men's Club. The Tacoma Elks had recently purchased the course. Pictured here are, from left, course manager Clyde Alexander, Allen (seated), Elks trustee Bill Jepsen, 1953 National Left-Handed Golf champion Jack Walters, and Erling O. Johnson. (Courtesy of Tacoma Public Library.)

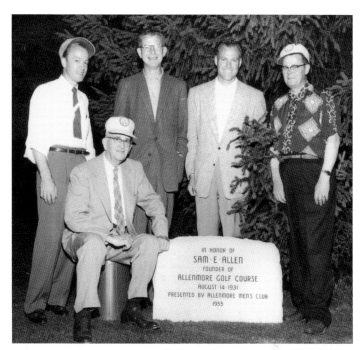

EDWIN EISENHOWER. Pres. Dwight D. Eisenhower (second from left) and his wife, Mamie, are shown at the College of Puget Sound on October 18, 1956. His brother Edwin (far right), a member of Tacoma Country & Golf Club, was the better golfer of the two. Analyzing Ike's game, Edwin said, the president "does not shift his weight correctly . . . over-pivots . . . takes too long a back-swing . . . has a good grip . . . and he has a little trouble on the greens." (Courtesy of Tacoma Public Library.)

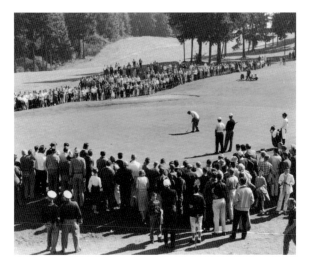

ARNOLD PALMER. This photograph was taken on the final day of the 1960 Carling Open, held in September at Fircrest Golf Club. Palmer, who had already won over $70,000 that year, was hoping to add the $3,500 first-prize money. He finished nine strokes behind Ernie Vossler of Midland, Texas, and pocketed a mere $250. On his 66th birthday, September 10, 1995, Palmer shot his age for the first time at Inglewood Country Club. (Courtesy of Tacoma Public Library.)

TACOMA ATHLETIC COMMISSION. Athletes, including four golfers, are recognized in 1970 by the Tacoma Athletic Commission. Shown here being honored for their contributions to golf are Harry Givan (standing, second from left), singer Pat Boone (seated left), Arnold Palmer (seated center), and Ken Still (seated right). When he was 11 years old, Givan aced the 12th hole at Inglewood and later shot 61 at Broadmoor. He captained the UW golf team and was on the 1936 Walker Cup team. (Courtesy of Tacoma Public Library.)

INTRIGUING CHARACTERS

MERRY LINDA ANDERSON.
Anderson was the defending
champion of the Washington
State Women's Golf Association
tournament at the time of this
1961 photograph, when she was
21. Anderson also won the 1960
Tacoma Women's Golf Association
championship and would go
on to capture a second title at
the event in 1963. (Courtesy
of Tacoma Public Library.)

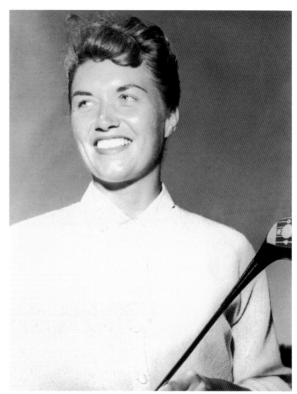

OCKIE ELIASON. Oscar "Ockie"
Eliason got a hole-in-one in the
second round of the Greater Seattle
Open, held at the Broadmoor Golf
Club in September 1964. Sponsored
by the Carling Brewing Co., the
trophy for the feat was a golf ball
atop a beer bottle. Eliason was
the golf pro at the Lakewood Golf
Range in Tacoma. He made his ace
on the seventh hole. It was the third
year in a row that someone won the
$10,000 hole-in-one prize. (Courtesy
of the Shanaman Sports Museum.)

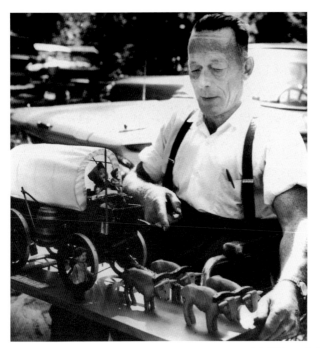

MAHON RANCH. Lloyd Medley, pictured in 1966, carved a wagon train with a team of oxen, representing the wagon train that carried the Longmire family over the Cascades in 1853. Their last stop was at the Mahon ranch, which became the Brookdale Golf Course. A plaque commemorating the event is at the golf course. Medley is a descendant of the Longmires, who were important in the exploration and development of Mount Rainier in the late 19th century. The visitors' services center in the national park is named for James Longmire. (Courtesy of Tacoma Public Library.)

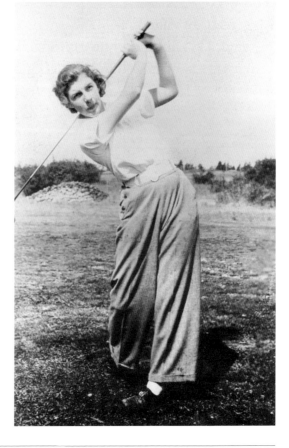

JOAN MAHON ALLARD. Brookdale Golf Course is located in Tacoma, on the former Mahon ranch. Joan Mahon Allard is a descendant of the homesteading family. She shot a 72 at that course when she was 17 and became women's state champion that same year. A tiny Mahon family cemetery is located at Brookdale Golf Course. (Courtesy of Shanaman Sports Museum.)

INTRIGUING CHARACTERS

GOLFING MACHINE. Self-taught engineer Homer Kelley spent decades studying the technical aspects of the golf swing. He referred to the swing as the "Golfing Machine," the title of his complex, controversial, and influential 1969 book. At his house in Seattle's Wedgwood neighborhood (seen here in 1941), Kelley trained professionals to use these principles. Former Broadmoor golf pro Ben Doyle taught these theories to Bobby Clampett, who expanded on them in his book *Impact Golf*. (Courtesy of Puget Sound Archives.)

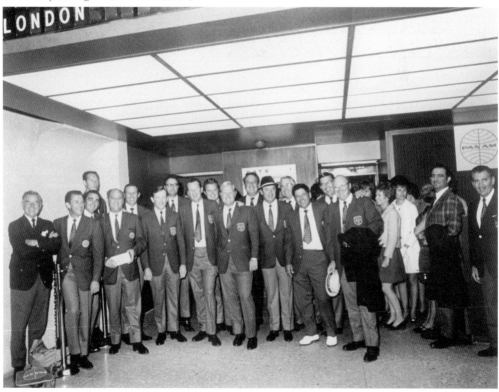

RYDER CUP, 1969. Ken Still was a member of the Ryder Cup team that competed against Britain in one of the most memorable cups. Taking place from September 18 to 20 at the Royal Birkdale Golf Club in Southport, England, the competition ended in a draw at 16 points each, the first draw in Ryder Cup history. Ken Still teamed with Lee Trevino (in white shoes) in a foursome on the first day and, later, in the singles matches on the last day. Still is fifth from the left in the first row, next to Jack Nicklaus. (Courtesy of the Shanaman Sports Museum.)

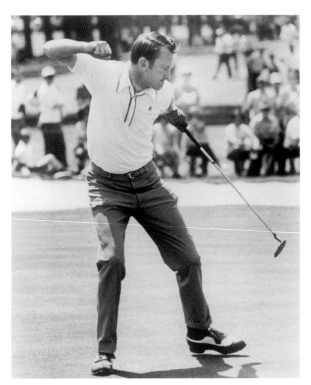

MASTERS, 1971. Ken Still reacts to a birdie putt at the 35th annual tournament, where his 4 under par landed him in a tie for sixth place. Still now spends time helping out at American Lake Veterans' Golf Course in Lakewood. The 1950s-built course was redesigned by Jack Nicklaus. American Lake, the country's only golf course set up explicitly for the rehab of wounded and disabled veterans, is completely run by volunteers. (Courtesy of Shanaman Sports Museum.)

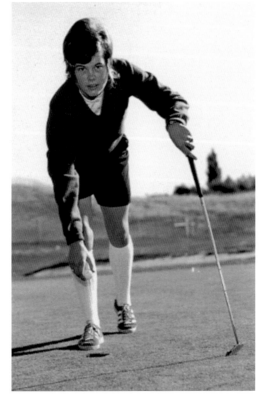

JO ANN WASHAM. By age 13, Washam had secured the club championship at Auburn Golf Course. Though only five feet, three inches tall, she played golf and basketball for Washington State University in the 1970s, courtesy of an Evans Caddie Scholarship. At WSU, she competed in national championships in both sports. Washam had three wins during her tour with the Ladies Professional Golf Association. (Courtesy of Washington State University Library.)

GOLF EXHIBITION
FEATURING
JO ANN WASHAM and NANCY LOPEZ-MELTON
– SEPTEMBER 29, 1980 –
FIRCREST GOLF CLUB

CLINIC 1:30 P.M. – GOLF 2:00 P.M.

**PROCEEDS TO BENEFIT MARY BRIDGE
CHILDRENS HEALTH CENTER
JR GOLF AND THE TAC**

ADVANCE $12.50 – GATE $15.00 001740 **No Refunds**

WASHAM AND LOPEZ. In 1979, Jo Ann Washam and Nancy Lopez paired up to win a Ladies Professional Golf Association team tournament. They came together again in 1980 for a charity golf exhibition at Fircrest Golf Club. The event, scheduled for September 29, was postponed until September 30 when the Dallas LPGA event went long. Nancy Lopez lost that match to Jerilyn Britz in a second sudden death. (Courtesy of Shanaman Sports Museum.)

TWO BLOCKS FROM LINKS. The proximity of the childhood home (pictured here in 1937) of Fred Couples to the Jefferson Park Golf Course significantly influenced the young golfer's game. Couples worked at the driving range, gathering up golf balls—a job that included some free golfing privileges. But that was not enough for the golf-obsessed youngster. Short of cash, he would often sneak onto the course to get in some extra rounds. (Courtesy of Puget Sound Archives.)

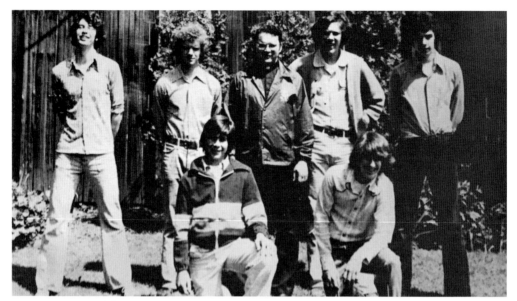

FRED COPPOLA? Though Fred Couples played on the Fighting Irish golf team at O'Dea High School, his family heritage is Italian and Croatian. His paternal grandfather Americanized the original name of Coppola to Couples. The 1975 golf team is seen here in the O'Dea yearbook. From left are (first row) Couples and Ron Mozzone; (second row) Tim Maguire, Dave Poplawski, Brother Patitucci, Paul Desimone, and Ken Wisemen. (Courtesy of O'Dea High School.)

KENNY G. When Kenneth Gorelick tried out for the jazz band his first year at Seattle's Franklin High School in the 1970s, he did not make the cut. But he did make the golf team. The renowned saxophonist eventually gained the first chair in the band and became captain of the golf squad. He is pictured here at left with fellow sax players Dean Mochizuki (center) and Dan Ko. Kenny G and his low handicap still hit the links. (Courtesy of Franklin High School.)

INTRIGUING CHARACTERS

GOLFIANA

GOLFIANA. Golf was listed as one of Tacoma's best recreational assets on this 1953 billboard. Several of these 30-foot plywood signs were placed on state highways as part of the Tacoma Chamber of Commerce's campaign to entice golfers and other sportsmen to the area. The state made $134 million a year in tourism at the time, and the City of Tacoma was attempting to get a bigger portion of vacationers' dollars from leisure activities by touting its attributes. (Courtesy of Tacoma Public Library.)

EXPLODING GOLF BALL. This 1910 photograph of the interior of Seattle Country Club shows a casual yet elegant room designed to create a tranquil atmosphere. In 1913, it was not tranquil for one caddie at the club who received serious burns when he cut open a golf ball that exploded, sounding like a small-caliber firearm. The newer balls did not contain acid, but older balls were still in circulation, which is why the caddies were repeatedly warned not to cut into golf balls of any description. (Courtesy of University of Washington Special Collections.)

UW GOLF COURSE. The links became an airfield in November 1920, before the first game in the new Husky Stadium. Pilot Dave Logg made an emergency landing, flipping the biplane, revealing "Welcome Dartmouth" written on the underside of its wings. The Huskies lost the inaugural game 28-7 before the largest Northwest crowd to that time to see an athletic event. An aerial photograph of the University of Washington golf course is at the front of this book. (Courtesy of University of Washington Special Collections.)

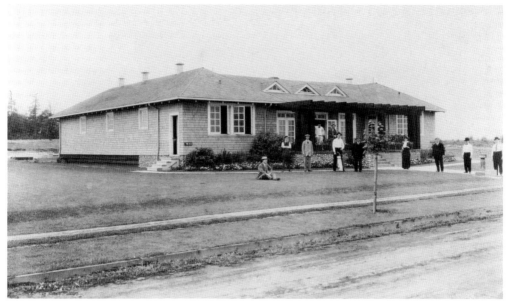

BLAZE TAKES CLUBHOUSE. Pictured in 1914, the U-shaped clubhouse at Jefferson Park Golf Course was destroyed by fire on December 1, 1919. Over 600 club members lost their drivers, brassies, putters, irons, balls, bags, shoes, and knickers. Albert J. Schoephoester was the only member who had insurance. With so many golfers losing all of their supplies, area sporting-goods stores were depleted. This cartoon of children offering substitute golf equipment to a crying golfer ran in the *Seattle Star* on December 2, 1919, under the heading, "Twill Be Some Time Ere They Will Slam Scotch Confetti." (Above, courtesy of Seattle Municipal Archives; below, courtesy of *Seatle Star*.)

GOLF SHOES. It all started in 1901 at one tiny shoe store. The first Nordstrom store was called Wallin & Nordstrom and was located in downtown Seattle. As this 1924 advertisement from the *Seattle Daily Times* shows, the store sold golf shoes. It has been more than 100 years since it opened, and Nordstrom still sells golf shoes—and a few other items, as well. (Courtesy of *Seattle Daily Times*.)

ACE OF CLUBS. This playing card featuring the Broadmoor Golf Course came from a 1952 deck of cards published to celebrate the centennial anniversary of Seattle. Each card featured a photograph of a prominent Greater Seattle landmark. The Broadmoor Golf Course, designed by architect A. Vernon Macon, was aptly featured on the ace of clubs. (Author's collection.)

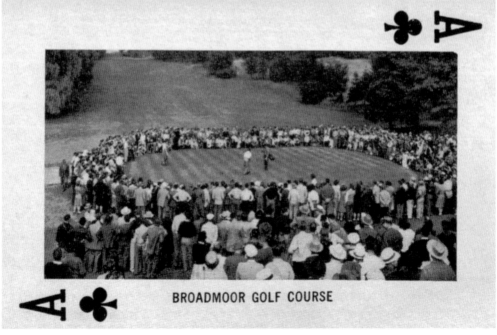

BROADMOOR GOLF COURSE

LAKE UNION GOLF LINKS, 1930s. Situated on a hillside, this nine-hole, small-scale course was also known as the Aurora Golf Course, because it was located on the east side of Queen Anne Hill, bordered by Aurora and Taylor Avenues and Galer and Blaine Streets. Local champion golf professionals Walter Pursey and Frank Rodia inaugurated the 1,121-yard course with a two-man tournament. Constructed to make the most of its alpine-like setting, the links looked more like a goat's paradise than a golf course. The 27-par links had holes intended for pitch-and-putt and irons, and a few longer holes for woods. The diminutive golf course became another victim of the Great Depression. (Both, courtesy of Seattle Municipal Archives.)

GOLF WRITER. John Dreher was mainly known as the *Seattle Times* golf writer who moved the sport from the society pages to the sports pages, until George Weyerhaeuser was kidnapped in 1935. Ransom was paid, and Weyerhaeuser was released. On a tip, Dreher found the child and interviewed him on the drive home. Dreher's golfing buddy H. Marfield Bolcom (in profile at left) answered the Weyerhaeusers' door, grabbed George, and pushed Dreher away. But Dreher got the scoop, and his story ran in every newspaper in the country. George eventually became president of Weyerhaeuser Company. When one of the kidnappers was released from prison, Weyerhaeuser hired him. (Courtesy of Tacoma Public Library.)

SLOT MACHINES. In 1939, deputies raided the Sand Point Country Club and removed slot machines to determine if they violated the gambling law. Earlier that year, confiscated machines were destroyed with a sledgehammer in Tacoma (pictured) in an attempt to rid the city of vice, graft, and corruption. Later, in 1955, the Supreme Court of the State of Washington ruled against slot machines. Tacoma Country Club complied by removing its machines, which had been a nice source of revenue. (Courtesy of Tacoma Public Library.)

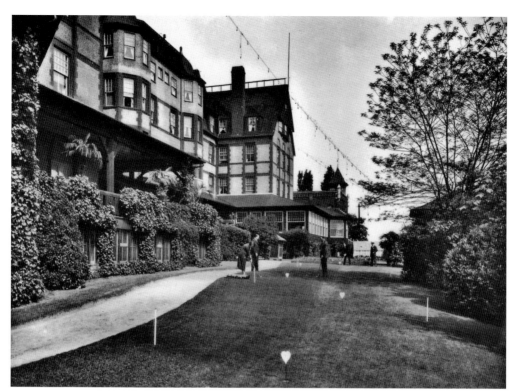

HOTEL MINI COURSE. A $125,000 remodel of the Tacoma Hotel in 1925 included a nine-hole putting green with a view of Puget Sound. Advertisements for the earliest hotel in Washington Territory to have first-class amenities asked guests to bring their golf clubs for their weekend vacations, because it also offered access to the Tacoma Country Club. Stanford White, architect of what is believed to be America's oldest clubhouse, at Shinnecock Hills Golf Club in New York, also designed the Tacoma Hotel in 1884. The landmark hotel, spanning a square block, was destroyed by fire on October 17, 1935 (Both, courtesy of Tacoma Public Library.)

GOLF PATCH. Medina's Overlake Golf Club opened in 1927 before a bridge was built across Lake Washington, so, many Seattleites accessed the course by ferry or boat. The course closed during the Great Depression and reopened in 1953 with a new name, Overlake Golf and Country Club, as seen on this vintage green-and-white golf patch. Prominent Pacific Northwest golf architect A. Vernon Macan designed the newer course. (Author's collection.)

TACOMA GOLF ASSOCIATION. Fort Steilacoom Golf Course joined 19 other courses when it became a member of the Tacoma Golf Association in 1971. Membership had declined since the 1950s, but the organization, established in 1931 to offer competition for amateurs, would continue to flourish. Today, as one of America's oldest golf associations, it provides numerous opportunities for its members, including junior and senior tournaments. (Author's collection.)

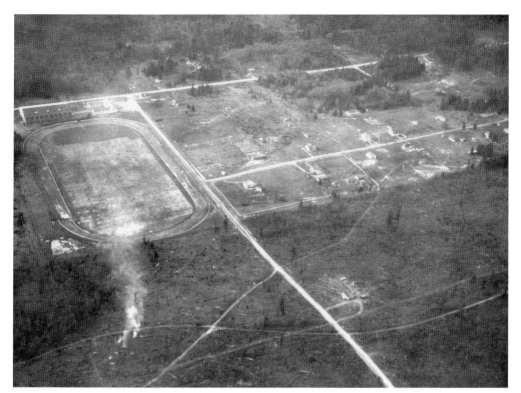

GOLF AND POLO. As golf courses started to fill the local landscape, the area polo fields slipped into oblivion. Above are the Olympic Riding & Driving Club (left) and Jackson Park Golf Course (right) in 1927. The Olympic Riding Club was later renamed Will Rogers Field in honor of the humorist, who played his last polo game there. Rogers is the horseman on the left in the below photograph, taken on August 6, 1935. The next day, he flew with pilot Wiley Post to Alaska, where they both perished when their plane crashed near Point Barrow. (Above, courtesy of Seattle Municipal Archives; below, courtesy of Museum of History and Industry.)

SAND POINT GOLF. In 1956, Anne Quast won the Washington State Women's Amateur at Sand Point. Before she was a Stanford graduate and before she appeared on the cover of *Sports Illustrated*, Quast was a girl on the boys' golf team at Marysville High School in the 1950s (above). An eight-time Curtis Cup member, Quast also won the Woman's British Amateur and several women's USGA titles. Following the trail blazed by Edean Anderson, Quast, along with Joanne Gunderson, Pat Lesser, Ruth Jessen, and Peggy Conley, dominated the courses in the 1950s. John Hoetmer, a golf pro on the leather bag tag below, was hit by a golf ball and lost vision in an eye but continued to win tournaments. At age 70 in 1983, Hoetmer got his 18th hole-in-one. William H. Hagans (below) served as treasurer of the Sand Point Country Club. (Above, courtesy of Marysville High School; below, author's collection.)

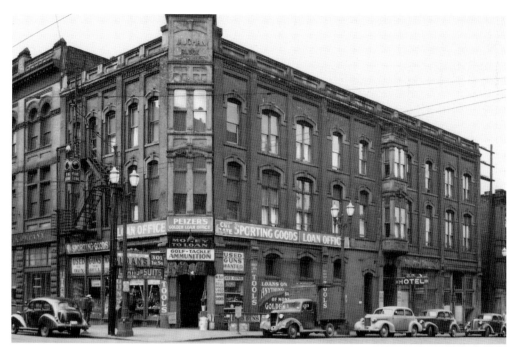

GOLF TACKLE AMMUNITION, 1945. Among the signs adorning this Seattle building at First and Main Streets are the following: "Money to Loan," "Used Guns Wanted," "Cut-Rate Sporting Goods," "Loans on Anything," "Tools," and "Good Used Logger Shoes." The sign directly above the center door reads, "Golf Tackle Ammunition." The store, at 301 First Avenue South, was robbed many times. (Courtesy of Museum of History and Industry.)

EDDIE BAUER FACTORY. In the 1920s, Eddie Bauer Sporting Goods in Seattle not only sold golf equipment but also purchased used golf balls for 20¢ each and repainted them. It sold three to five refurbished golf balls for $1. By the time this 1945 photograph of the Eddie Bauer factory was taken, it was making golf clothes as well. According to a 1928 advertisement, a man could buy his wife a Bauer's Beginner's Set—"four good clubs and a genuine Par Bag"—for $8.75. He could trade it in within six months for a better set and get a $7.50 allowance. (Courtesy of Museum of History and Industry.)

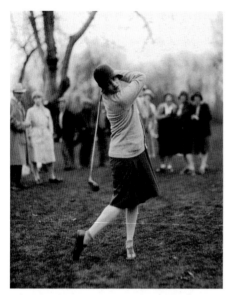

DRESS CODE, 1930. Golf was becoming more popular with Pacific Northwest women when this photograph was taken at the Seattle Golf Club in The Highlands. Mrs. J.C. Kilborne shows off her swing, wearing typical golf attire for females at that time. Women were not allowed to wear pants at Seattle Golf Club until 40 years later, in 1970. (Courtesy of Museum of History and Industry.)

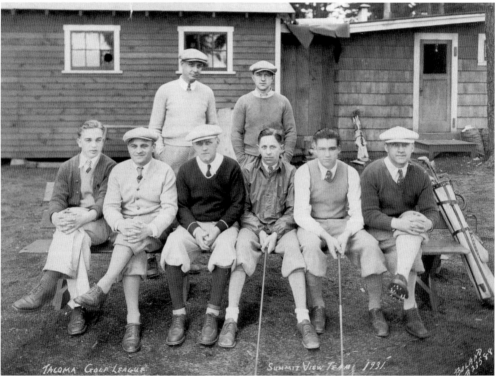

PLUS FOURS. The Summit View team, participants in the 1931 Tacoma golf league, are pictured here. Most of these men are wearing plus fours: trousers that extend four inches below the knee when fastened, and eight inches below when unfastened. This sporty, loose-fitting garment allows flexibility and helps pants stay dry and clean by keeping them above the vegetation. Plus twos are pants that extend two inches below the knee when secured, and four inches below when unattached. (Courtesy of Shanaman Sports Museum.)

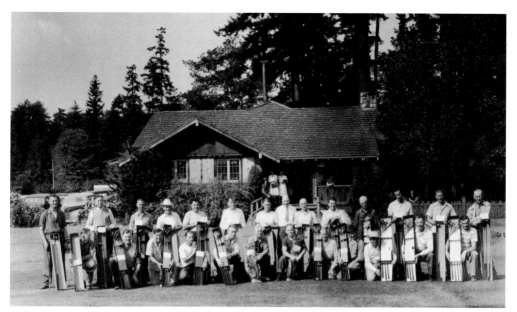

LIGHTNING STRIKES. Golfers show off their prizes at Brookdale Golf Club in 1943. At this course in 1939, golfers John Nelson and Dean Fallet escaped serious injury when they were knocked down after lightning struck a large tree, sending pieces of wood 150 feet over the fairway. According to the National Oceanic and Atmospheric Administration, lightning is uncommon in the Puget Sound area, because it lacks the temperature extremes needed to generate these storms. (Courtesy of Tacoma Public Library.)

SNOW DAY ON THE COURSE. West Seattle Golf Course became a winter playground on January 14, 1950. Between January 12 and January 14, a total of 26.8 inches of snow fell. Then, on January 25 and 26, an additional 12.4 inches fell. When the record-breaking snowfall stopped, the record-low temperatures continued, with nine days of temperatures below 10 degrees between January 12 and February 4. (Courtesy of Museum of History and Industry.)

GOLF IN SEATTLE AND TACOMA

Dancing Cigarettes, 1951. The legs under this pack of cigarettes belong to the daughter of a Tacoma Country Club member. The club hosted a yearly children's Halloween party. Television emcee and Palm Springs golf tournament host Dennis James appeared with the dancing Old Golds in some of the 1950s television advertisements that propelled the frolicking pack into stardom. James, who golfed in Pat Boone's 1969 Celebrity Golf Classic at Ocean Shores, Washington, died in 1997 of lung cancer. (Courtesy of Tacoma Public Library.)

Transportation to Golf Courses. Players cannot golf if they cannot get to the course. In the early days, roads, if they existed, were crude; automobiles were expensive; and bridges were sporadic. Proximity to the public was important to a golf course's survival. Golfers got to courses by foot, car, bicycle, trolley, train, and ferry. The 1940 collapse of the Tacoma Narrows Bridge (pictured) connecting the Kitsap Peninsula and Tacoma surely altered the golf plans of a few players. The suspension bridge was rebuilt 10 years later. (Courtesy of Tacoma Public Library.)

CHAMBERS BAY

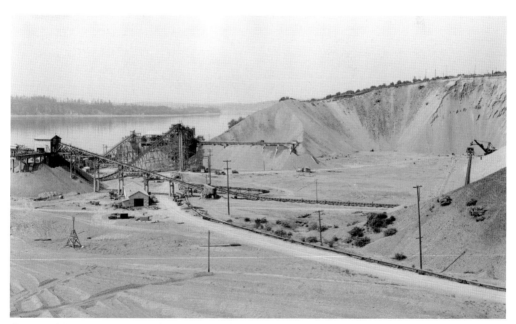

GRAVEL MINE, C. 1945. Before it was sculpted into a golf course by golf-architect Robert Trent Jones Jr., Chambers Bay was a sand and gravel pit—the perfect foundation for a world-class golf links. Though the terms "golf links" and "golf course" are used interchangeably, the only true links in this region are Chambers Bay in University Place, Brandon Dunes in Oregon, and Kings Links by the Sea in British Columbia. A links course usually has very few trees, is on a large body of water, has sandy soil, and has a natural landscape that is open to the elements. (Courtesy of Washington State Historical Society.)

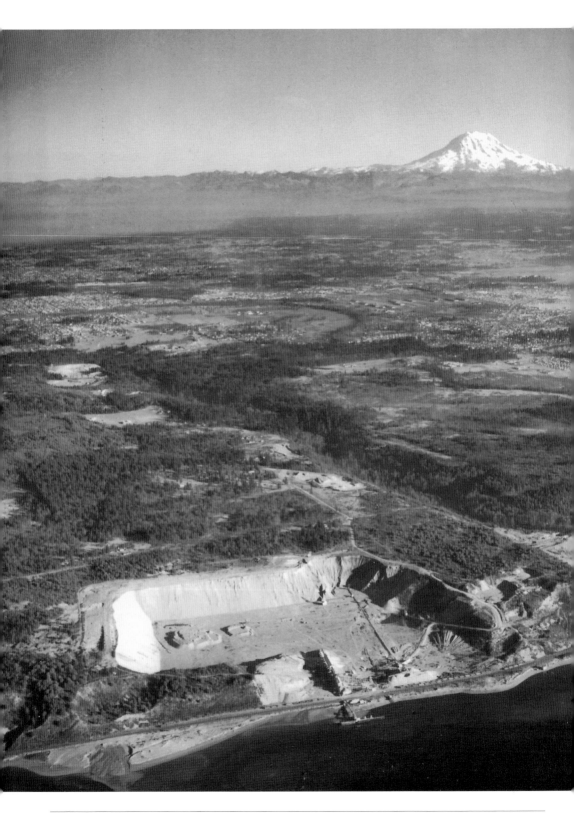

CHAMBERS BAY

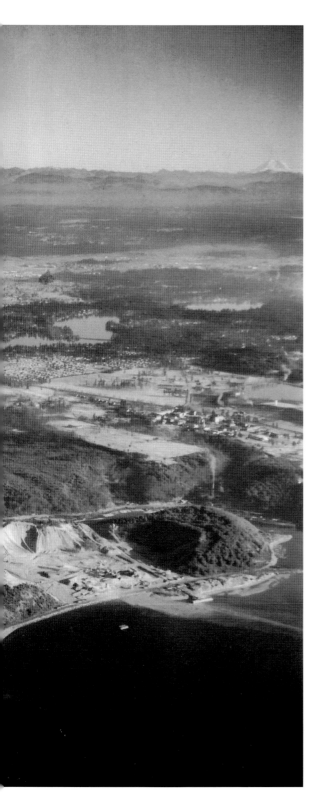

PIONEER SAND AND GRAVEL. This 1963 panoramic photograph takes in a great swath of southeastern Pierce County and features the two gravel pits operated by Pioneer Sand and Gravel. The southernmost pit (right), backed by Chambers Creek, is now the site of the Chambers Creek Wastewater Plant. At the site of the northern gravel pit (left) is now the world-class, 250-acre, links-style Chambers Bay Golf Course. The whole property, which includes a recreation area, was purchased by Pierce County for $33 million in 1992. While the urban south Tacoma sprawls in the background, the area around the Chambers Creek property was still largely undeveloped in the early 1960s. To the north of Chambers Creek, bisecting the photograph, is University Place. To the south is Lakewood. At center right, just above Steilacoom Lake, aircraft can be seen parked at McChord Air Force Base. Looming over it all is majestic Mount Rainier. (Courtesy of Tacoma Public Library).

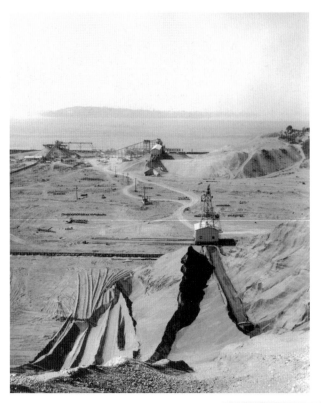

A CENTURY OF MINING. These photographs, from 1963 (left) and 1946 (below), offer a closer view of Pioneer Sand and Gravel as a functioning quarry. What looked like a mere sandpit to most people was a dream to golf architect Robert Trent Jones Jr. His father, Robert Trent Jones Sr., designed over 500 golf courses. His brother Rees Jones renovated Sahalee Country Club in Sammamish, shaping it into a course that consistently makes *Golf Digest*'s top 100. The Sahalee Golf Course has something Chambers Bay lacks: trees, big trees. It is like a Christmas tree farm on steroids. (Both, courtesy of Tacoma Public Library.)

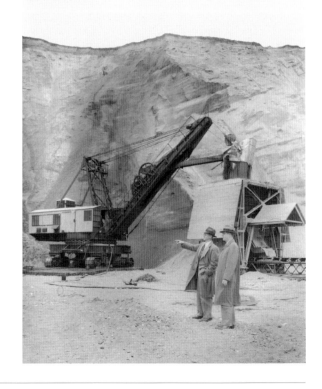

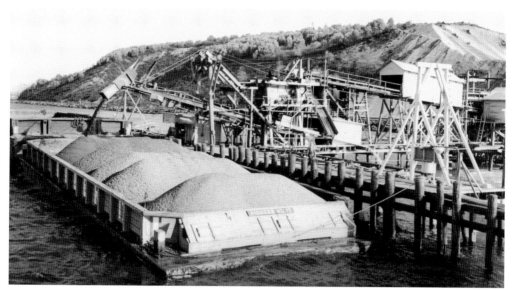

TOP-RATED SAND. Gravel from the quarry is being poured into barge No. 17 in this 1949 photograph. The tugboat *Seattle* will take it through Puget Sound to its next destination. The gravel was also transported in open-hopper cars on railroad tracks that ran around the shores of the pit. The functioning railroad is still there. Pioneer Sand and Gravel specialized in building materials and "Tru-Mix" concrete, which was used for projects all over the Pacific Northwest, including Safeco Field. The gravel from this open-pit mine, also used for road construction, was the highest quality available. (Courtesy of Tacoma Public Library.)

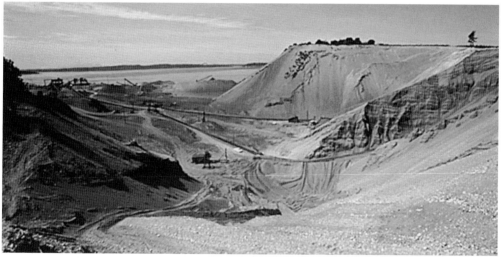

FUTURE CHAMBERS BAY. This 1970 photograph offers another look at the gravel pit that will become Chambers Bay. Other names considered for the course include the following: The Chamber, The Links at Chambers Bay, The Links at Chambers Creek, The Links at Olde Pit, The Links at Puget Dunes, Miners Graveyard, The Olde Ruins Golf Links, Puget Dunes, Quarry Dunes, Ruins Dunes at Chambers Bay, Sea Star, Steilacoom Straits, Whisper Hollow, Whisper Ridge, Whisper Straits, and Wild Canary. (Courtesy of National Archives and Records Administration.)

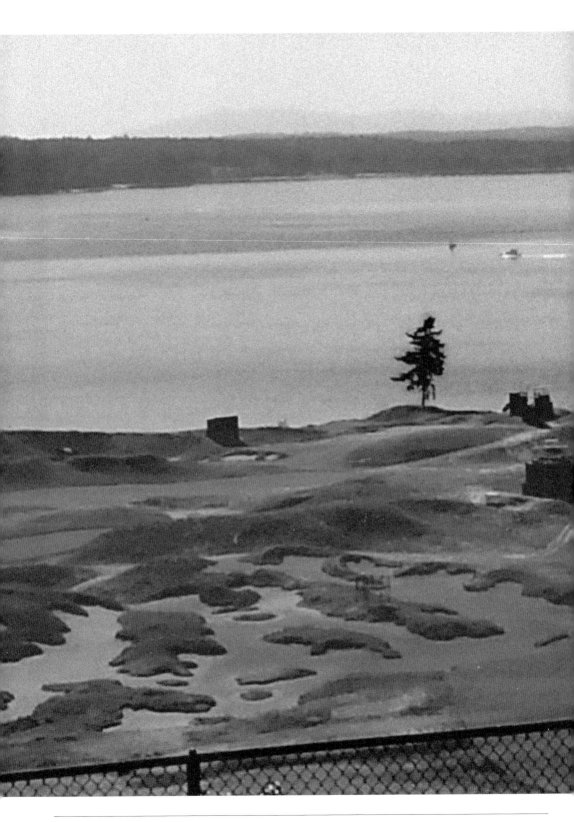

CHAMBERS BAY

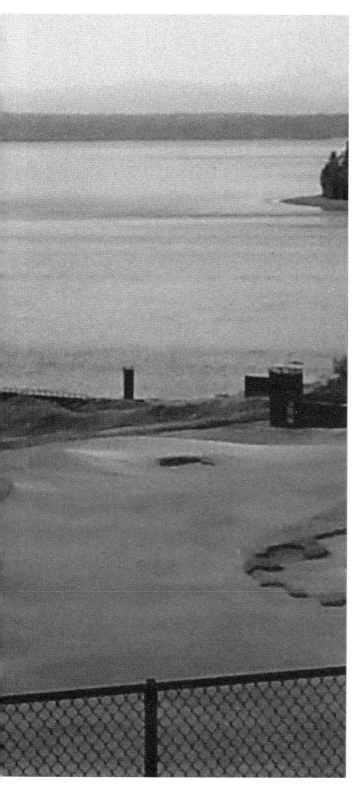

LONE FIR, 2015. That one little tree adorning Chambers Bay, just past the 15th green, has become an iconic presence on the links—not just for golfers, but for locals who enjoy the park and trails built around the course. The Douglas fir was vandalized in 2008 when a section of the trunk was brutally hacked out, causing severe damage. Tree expert Neal Wolbert proved to be a bit of a tree whisperer, nurturing the fir back to health. Though scarred, it survived to witness the first course in the Pacific Northwest to host a US Open. It was the largest athletic event of any sport ever held in this region. Beyond the tree is Puget Sound. Three islands are visible from Chambers Bay: Anderson, Fox, and McNeil. In the distance is a hazy view of the Olympic Mountains. (Author's collection.)

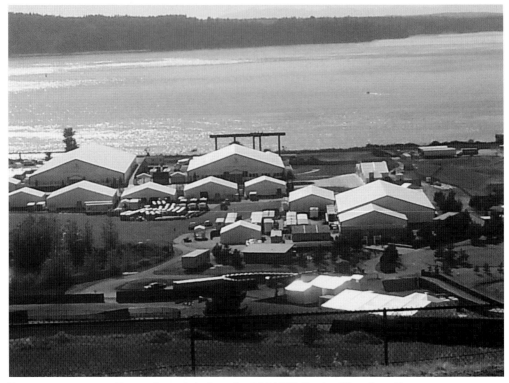

PREPPING FOR THE OPEN. A week before the 2015 US Open, Chambers Bay is turning into a little village. The area is cordoned off, volunteers are scurrying, and tents are popping up on the landscape. Residents in the area have rented out their houses for thousands of dollars. Below, golfers check out the greens on a practice day, two days before the event. This would be the first US Open to be played entirely on fescue grass. The fescue grass used on the greens was a combination of poa annua grasses. The different types of grass grew at different rates, which made the greens bumpy, especially at the end of the day. This would prove to be a major grievance during the tournament. The Pierce County course was not responsible for the uneven greens; it was the USGA's call to use this particular combination of grasses. (Above, author's collection; below, courtesy of Lee Sorrentino.)

US OPEN. When Jordan Spieth won the 2015 US Open at Chambers Bay, in University Place, Washington, it was a homecoming for Spieth's caddie, Michael Greller. He is a former teacher from University Place who held his wedding at Chambers Bay. Will this pair have an opportunity for a repeat performance at this captivating location? Pierce County would love to host this event again on its municipal course. Is it too much to ask for another fairy-tale ending on this former gravel pit? Will professional golfers Josh Persons and Tom Hoge get another chance to play in a US Open on a links that is 100-percent fescue grass? Their bags are seen here on a practice day at the 2015 US Open. (Courtesy of Lee Sorrentino.)

DISCOVER THOUSANDS OF LOCAL HISTORY BOOKS FEATURING MILLIONS OF VINTAGE IMAGES

Arcadia Publishing, the leading local history publisher in the United States, is committed to making history accessible and meaningful through publishing books that celebrate and preserve the heritage of America's people and places.

Find more books like this at
www.arcadiapublishing.com

Search for your hometown history, your old stomping grounds, and even your favorite sports team.